IMAGES
of America

WILKINSBURG

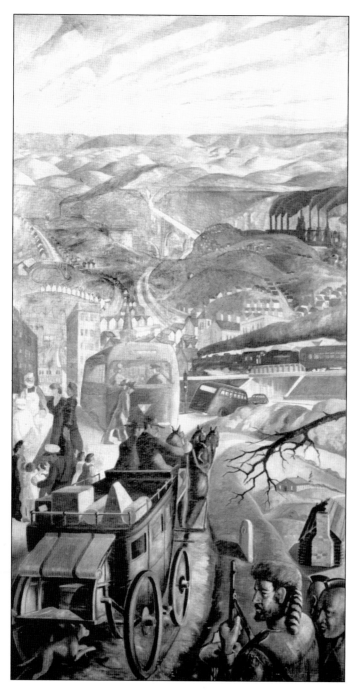

The History of Wilkinsburg was painted on a wall of the municipal building by Wilkinsburger Harold "Dutch" Carpenter in 1945. In the foreground are early inhabitants of the area. Behind them are Rippey's log tavern, the Seven Mile Stone, and old Beulah Presbyterian Church. The coach-and-four, the trolley, and the railroad train illustrate transportation history. Doctor and patient represent Columbia Hospital. The church steeple in the center symbolizes the borough as the "City of Churches." The Penn Lincoln Hotel and Wilkinsburg's first skyscraper appear at middle left. The William Penn and Lincoln Highways wind over the rolling hills. Penn Avenue climbs the hill where schoolchildren play at Graham Field. In the distance are the Westinghouse plant, George Westinghouse Memorial Bridge, and the smoking steel mills, important influences on the local economy. Thus is Wilkinsburg's history summarized by an artist's brush.

On the cover: On Saturday, October 5, 1912, Wilkinsburg celebrated the silver anniversary of its incorporation as a borough. The morning featured a football game at Duquesne Country and Athletic Club Park in which the Wilkinsburg Red and Blue beat Crafton High School 18-0. For the afternoon's grand parade, Semple School students decorated this impressive float, which was built on a farm wagon drawn by a four-horse team. (Courtesy of the Wilkinsburg Historical Society.)

IMAGES
of America

WILKINSBURG

Wilkinsburg Historical Society

ARCADIA
PUBLISHING

Published by Arcadia Publishing
Charleston SC, Chicago IL, Portsmouth NH, San Francisco CA

Printed in the United States of America

Library of Congress Catalog Card Number: 2006930464

For all general information contact Arcadia Publishing at:
Telephone 843-853-2070
Fax 843-853-0044
E-mail sales@arcadiapublishing.com
For customer service and orders:
Toll-Free 1-888-313-2665

Visit us on the Internet at www.arcadiapublishing.com

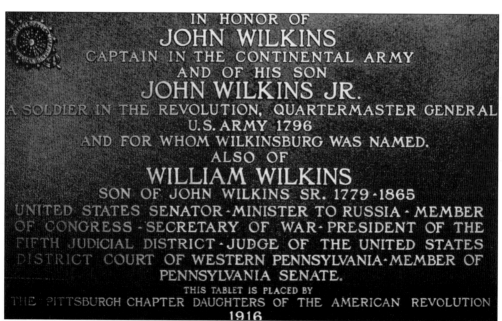

This tablet, placed by the Pittsburgh chapter of the Daughters of the American Revolution in 1916, commemorates the lives of three Wilkins men and notes that Wilkinsburg was named for John Wilkins Jr. (1761–1816). The bronze tablet was installed at the Wilkinsburg High School but was relocated inside the front doors of the Wilkinsburg Municipal Building in 1976.

CONTENTS

ACKNOWLEDGMENTS

The Wilkinsburg Historical Society thanks James B. Richard and Anne Elise Morris for their leadership of the committee that produced this book. Thanks, too, to Jean Dexheimer for editing the text and to the rest of the committee: Marilyn Karpinski, Joel Minnigh, Thomas Morris, Edgar Taylor, Marian Thompson, William Zimpleman, and Justin Wideman, a Wilkinsburg High School student. The committee thanks the staff of Arcadia Publishing for their guidance.

The photographs and historical materials were borrowed from the archives of the Wilkinsburg Historical Society, the Wilkinsburg Public Library, and many members of the community. The images selected were borrowed from: James V. Ballantyne, Ernest K. Baur, Lorraine B. Bode, Richard L. Bowker, Joyce S. Chalfant, Marvin Chidester, Edward Dinneen, Mary Grace Dorsett, Richard J. Harris, Dale Hedding, Yvonne James, Justin M. Johnson, Karen S. Kurplewski, Janice Kregar Levine, Henry J. Lotz, Kay Topper Maxwell, Catherine McDonough, James D. Moore, Thomas K. Morris, Richard J. Muzzey, Eugene Reichenfeld, Patricia M. Sheckler, Thomas W. Stephens, Chester J. Suski, Edgar R. Taylor, Barbara A. Warrick-Fischer, Olive Wepfer, Mike Wheat, Randy Whittingstall, John G. Wilkins, William Zimpleman, Carnegie Hero Fund Commission, Concordia at Rebecca Residence, Christian Church of Wilkinsburg, Hayes School Publishing, Mifflin Avenue United Methodist Church, National Baseball Hall of Fame, PNC Bank, Scholastic Inc., Swissvale Public Library, Wilkinsburg School District, Wilkinsburg Stamp Club, and WTAE-TV.

The committee offers a very special thanks to Richard J. Muzzey of Wonday Film Service for his time and expertise as a photograph finishing engineer and photographer. Thanks, also, to South Avenue United Methodist Church for providing storage space and the meeting place.

This book is dedicated to the founders of the Wilkinsburg Historical Society who, in 1940, published *Annals of Old Wilkinsburg and Vicinity: The Village 1788–1888* and to all past and present members of the society.

INTRODUCTION

Wilkinsburg has a unique name. It is the only Wilkinsburg in the world, although it has not always been so named. A part of Wilkinsburg occupies a 266-acre tract of land originally called Africa. (It was the custom of the Pennsylvania land office to distinguish each land grant or patent with a name.) The Great Road to Fort Pitt ran through Africa. The tract was surveyed in pursuance of application No. 3122, entered in April 1769 by Andrew Levi Levy Sr., a land speculator. Levy conveyed the land to Gen. William Thompson by deed dated June 1788 for 40 pounds, 5 shillings. By the time the settlement was large enough to have a name, Col. Dunning McNair, a major landowner, dubbed it McNairstown. His stone mansion, Dumpling Hall, was a noted landmark.

Between 1800 and 1812, the village was at times called Wilkinsburg(h). By a deed dated September 1812, from McNair to Patrick Green, it was first officially registered as Wilkinsburgh. McNair named the town for his close friend Gen. John Wilkins Jr., who fought in the Revolutionary War.

The territory now occupied by the borough of Wilkinsburg was on the only road from east of the Allegheny Mountains to the headwaters of the Ohio River. The little band that accompanied George Washington on his memorable 1753 visit to the French forts passed through Wilkinsburg. So too did the French and Native American forces who defeated the English general Edward Braddock on that eventful day in July 1755. From that time on, the village and western Pennsylvania became familiar to the Native American trader, the pioneer settler, the Colonial soldier, and the "go west, young man, go west" adventurer.

After the expulsion of the French in November 1758, the building of Fort Pitt, and the permanent occupation of that site by the English, a major route to the East Coast became necessary and the Great Road (later Penn Avenue) between Philadelphia and Fort Pitt was opened. The Great Road attained an importance that only increased with time. Prior to the Fort Stanwix Treaty of 1768, vast tracts of forest between the Allegheny Mountains on the east and the Allegheny and Ohio Rivers on the west had been purchased. Settlers had already begun to occupy land around Fort Pitt and along the valley of the Monongahela River.

In the early history of western Pennsylvania, county boundary lines changed and new counties were formed as the colony acquired territory from the Native Americans. The location of Wilkinsburg affords a good illustration. At the time of the treaty of November 1768, Cumberland was the westernmost county in the colony, and the territory purchased from the Native Americans was annexed to it. Wilkinsburg, after the defeat of the French, passed successively through Cumberland, Bedford, and Westmoreland Counties before it finally settled down in Allegheny County.

Wilkinsburg grew very slowly after the death of Col. Dunning McNair in 1825. In 1833, James Kelly purchased an 856-acre parcel and a second parcel that had once belonged to McNair. Kelly owned over 1,000 acres but sold very little of it, and as a consequence, the village did not grow. Although it lay in a beautiful valley and was the suburb of a large city, it remained small and peaceful. In the late 1870s, when the settlement was over 100 years old, two blocks north of the railroad station the surroundings were as primitive as a rural village. In 1879, all that began to change. With all his valuable property and well advanced in years, Kelly showed an unaccountable reluctance to part with any land. He borrowed on his holdings to pay his property taxes until he owed over $300,000. To satisfy his indebtedness, everything he owned was sold at sheriff's sale; the banks bought most of it. Over the next decade, the land was subdivided and sold for many times the purchase price, and Wilkinsburg began to grow.

About the year 1871, state law allowed Wilkinsburg's taxable inhabitants to petition the court to become part of the city of Pittsburgh. Such a petition was filed, and in May 1873, the village of Wilkinsburg became part of Pittsburgh's 37th ward. Many people, and especially James Kelly, strongly objected. They appealed the decision all the way to the Pennsylvania Supreme Court where, in January 1876, they succeeded in having the annexation nullified.

Kelly's former holdings came onto the market in 1881. Although land in small parcels was then readily available, development was impeded by the lack of a municipal government. Until 1887, there were no sidewalks; the streets in spring and fall were impassable. A wagon stuck in the mire and remaining so for the greater part of the winter was a familiar sight. It was impossible to go out at night without a lantern, and even with one there was great danger. Tin cans and rubbish of every description filled the streets and bad smells filled the air from the stables in every block. There was great opposition from some residents to incorporating the borough. The first two charter applications were defeated because there were not enough signatures of taxable inhabitants. The third attempt was successful, and on October 5, 1887, the court granted a charter incorporating the town as the Borough of Wilkinsburg. The first election for town officers was set for the third Monday in February 1888.

Incorporation gave a great impetus to the growth and development of the community. People who had been discouraged and were planning to move gathered new courage and decided to stay. Interest in the community's real estate increased, and better-quality buildings were constructed. Local pride grew, as Wilkinsburg became a most desirable place to live. In the first four years of incorporation, Wilkinsburg's population increased from 2,500 to 6,000. Every street had sidewalks; water and sewer systems were in place. Streets were being paved with bricks, and streetlights were installed. There was a well-organized municipal government. The 19th century was ending.

As the new century began, 12,000 people called Wilkinsburg home, and the borough continued to grow. By 1910, the community had 19,000 residents, and by 1920, there were 24,403. There were six public schools, including a junior high school and a high school, 148 teachers, and 4,253 pupils. St. James Catholic School offered grades one through eight. By 1916, the Pennsylvania Railroad had replaced the town's dangerous grade-level crossings with rail overpasses. The town marked the end of World War I with a celebration for the military on Labor Day 1919. Through the Roaring Twenties and the Great Depression, Wilkinsburg continued to grow. By 1930, the population reached 29,639. In the mid-1930s, the voters of this "City of Churches" reaffirmed their desire to ban the serving of alcoholic beverages.

Many of Wilkinsburg's young men and women served in World War II. The population had leveled off to 29,853 in 1940 and then reached its peak of 31,418 in 1950. The social and economic changes of postwar America, and especially the extension of trolley lines and the affordability of private automobiles, began to impact community life. As this pictorial history ends in 1962, a redevelopment program was already under way.

One

BIRTH OF A VILLAGE

In April 1769, the Land Company of the Colony of Pennsylvania opened large tracts of land for sale in its western area. Andrew Levi Levy Sr. applied for a heavily forested 266-acre tract, which he named Africa. The village of Wilkinsburg was later sited in this tract. Levy sold the land to Gen. William Thompson in 1788. Thompson died within the year, and in May 1789, his heirs conveyed the patent to Col. Dunning McNair for 322 pounds, 10 shillings.

McNair laid out the street plan for a town he named McNairstown. The Great Road, now Penn Avenue, running east and west, was its center. Parallel to it on the south was a street named for his friend James Ross; to the north was a street named for William Wallace. Running north and south were two lanes: Horner Lane (now Wood Street) and Center Lane. Crossing the eastern hill was a Native American trail, later Water Street, now known as Swissvale Avenue. In 1799, McNair was elected to the state legislature, where he presented the bills to abolish slavery in Pennsylvania and to provide public schools. He proposed dividing the huge Allegheny County into a number of smaller counties and presented the bill, passed in March 1800, that created the western Pennsylvania counties that are known today.

The name Wilkinsburgh, with an *h*, first appeared in recorded deeds in 1812. The Wilkins family was among the most distinguished in early Pittsburgh. John Wilkins Sr. married three times and had 20 children, the first of whom was John Wilkins Jr. Another son was Judge William Wilkins, a United States senator and minister to Russia. Wilkinsburg was named for John Wilkins Jr., a close friend of McNair. Born in 1761, John Wilkins Jr. joined the Continental army as a surgeon's mate at age 15. Later Pres. George Washington appointed him brigadier general of the U.S. Army. John Jr. was also the first president of the Pittsburgh branch of the Bank of Pennsylvania. He died in 1816 at age 55 and is buried in the Wilkins family plot in Homewood Cemetery.

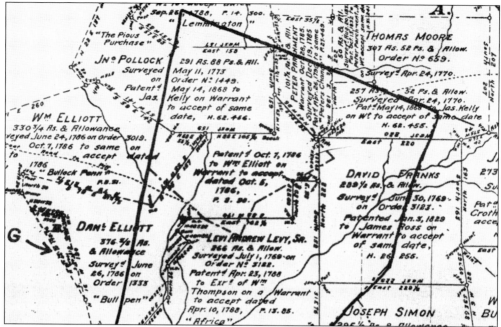

Wilkinsburg, outlined in black on the patent map above, was incorporated as a borough on October 5, 1887. It was located in Sterrett Township and was bounded by the city of Pittsburgh on the west and the townships of Wilkins and Braddock on the east. The borough included the 266-acre tract known as Africa, purchased by Andrew Levi Levy Sr. in 1769, which is shown at the bottom center.

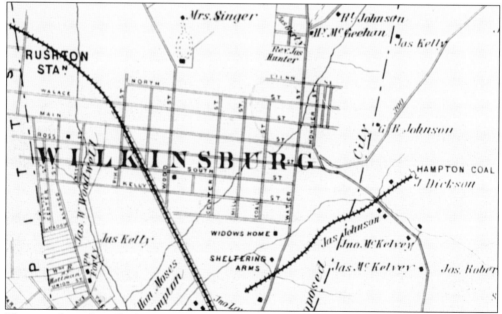

This map from the Allegheny County atlas of 1876, prepared by the G. M. Hopkins Company, shows the village of Wilkinsburg. From 1873 to 1879, all lands west of the proposed city line, seen on the right, were within the city of Pittsburgh. In 1788, the village was in Pitt Township; in 1821, it became part of Wilkins Township, and then part of Sterrett Township in 1879.

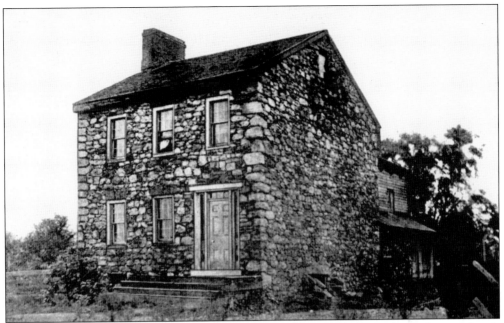

Dumpling Hall, the home built by Col. Dunning McNair in 1790, was located near what is now Hay Street and Kelly Avenue. Considered a mansion in its time, the home was named by a houseguest who thought the cobblestones embedded in mortar resembled apple dumplings. After McNair's death, James Kelly bought the house and lived there until he died in 1882. The home was torn down in 1905.

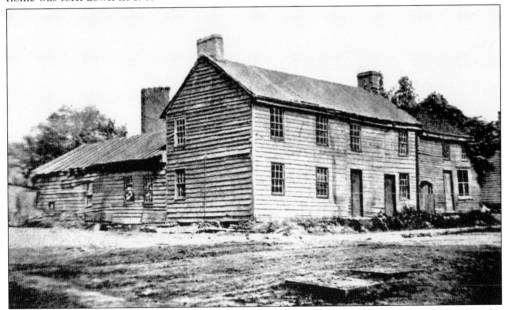

This large, rambling frame house, built in 1807 by contractor David Little, was situated at the northeast corner of what is now Penn Avenue and Wood Street. Its owner, James Horner II, was justice of the peace and had his office attached to the house. The Horner house was torn down in 1893 when the First National Bank purchased the property and erected a large stone building for its expanding business.

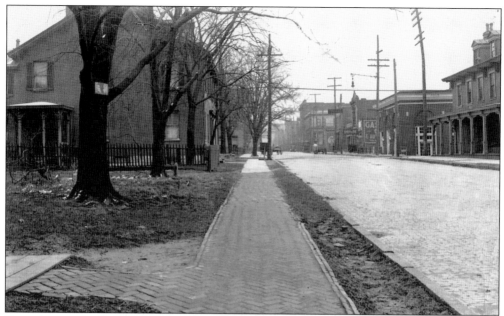

Penn Avenue, looking east in this 1914 photograph, was once known as the Pike, part of the Greensburg and Pittsburgh Turnpike. On the north side of the street, in front of the second tree on the left, is the Seven Mile Stone. It was erected in 1815 to mark the distance from the "Point in Pittsburgh." In 1942, the stone was moved to the front of the Wilkinsburg Municipal Building.

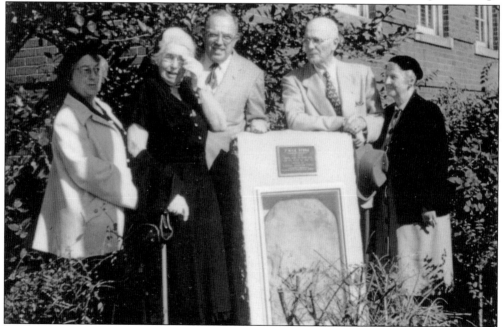

The Seven Mile Stone, one of the mile markers on the Greensburg and Pittsburgh Turnpike (now Penn Avenue), has been located, since 1942, in front of the municipal building on Ross Avenue. In October 1955, members of the Wilkinsburg Historical Society placed the stone in a glass-covered granite case. Society members from left to right are Ilka Stotler, Martha Black, Robert Carmack, and Dr. Thomas McFadden and his wife, Catherine McFadden.

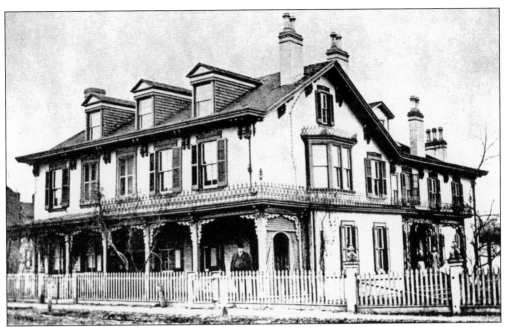

Seven Mile House, built in the 1840s on land first purchased by Abram Horback in 1835, was a well-known tavern. Located on the south side of the Pike, at Kelly's Lane (now Penn Avenue at Hay Street), it was diagonally across the street from the Seven Mile Stone. The house was a popular stopping place for turnpike travelers and a favorite resort for city families during the summer.

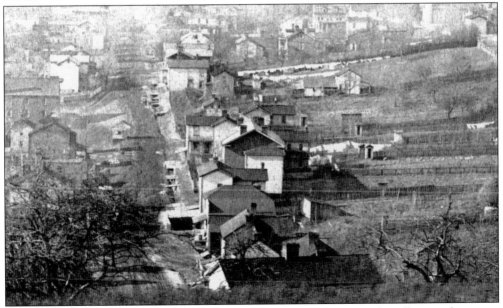

In 1818, the Greensburg and Pittsburgh Turnpike Road Company erected a tollgate at the corner of Water and Main Streets (now Swissvale and Penn Avenues). It was moved about 1878 because people were evading the toll by taking another route. This view, looking west on the unpaved Main Street from Montier Street, shows the new location of the tollhouse next to the gristmill on Coal Street.

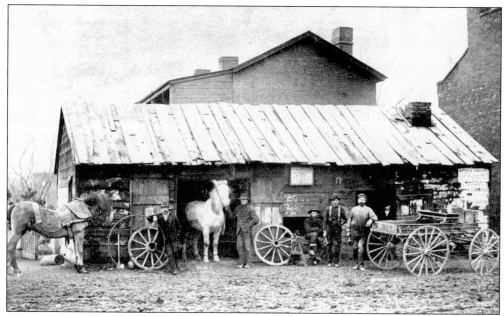

John Lacock, one of the early blacksmiths of Wilkinsburg, set up this shop near the southeast corner of Penn Avenue and Hay Street about 1850. John and his wife raised 15 children in the brick home behind the shop. To feed their family, the Lacocks grew their own vegetables in a long garden behind the home. Pictured here, workers take a break from the anvil and bellows of their trade.

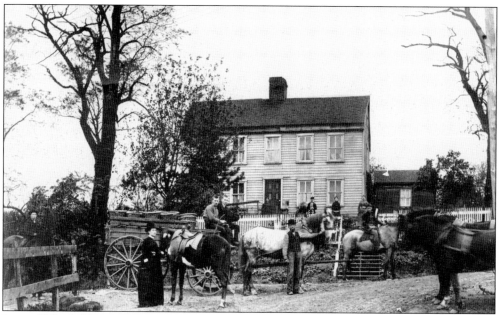

James Kelly held over 1,000 acres that included what is now Wilkinsburg, Edgewood, and Brushton. He acquired the land, most of it formerly Col. Dunning McNair's, in 1833 for $12,000. In 1879, the land was sold at sheriff's sale to satisfy over $300,000 in debt. Kelly's daughter Mary Kelly McCombs lived in this two-story house at Oakwood Street and Frankstown Avenue. She lost her home at the time of the sale.

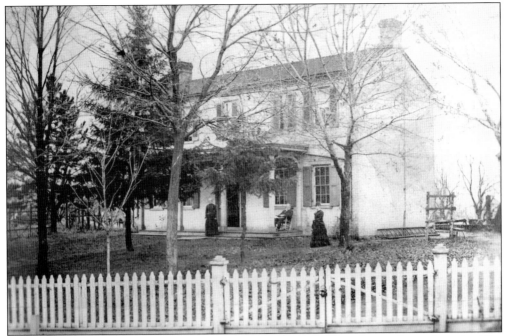

George Johnston's brick farmhouse, shown in this 1885 photograph, was located on the Pike where Graham Field is today. George inherited the farm from his father, Gen. John Johnston, who had received 620 acres as a grant for his service in the Revolution. The farm, later owned by George's sons James and Jonas, occupied most of the land west of Woodlawn Cemetery down to Water Street (later Swissvale Avenue).

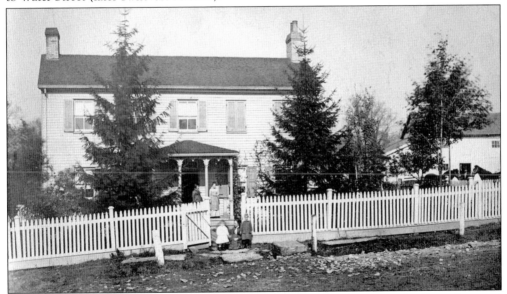

This 1837 house still stands at 2015 William Penn Highway, then known as the Greensburg and Pittsburgh Turnpike. The Reverend James Graham, who became pastor of Beulah Presbyterian Church in 1804, and his first wife had six children. Two of these children, Mary and Robert, later managed the house as an inn. A third Graham son, James, who farmed and burned lime, married in 1842 and settled in the house.

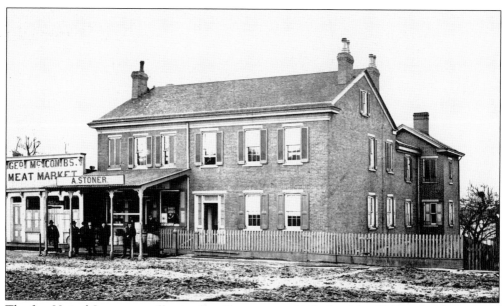

The first United States post office in the village was established in May 1840 under the name of Wilkinsburgh. Pres. Martin Van Buren named Abraham Stoner as postmaster. The post office was located in the storeroom of Stoner's dry goods store, pictured here at 732 Penn Avenue. After 50 years, in 1891, the final *h* was dropped, and the name of the post office became Wilkinsburg.

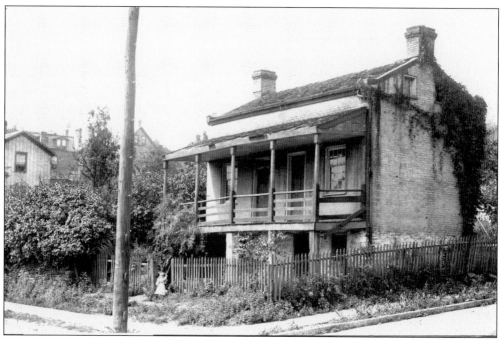

Alexander Hamilton, a distant relative of George Washington's secretary of the treasury, purchased land from James Kelly at the corner of Penn Avenue and Coal Street. Here he built Wilkinsburg's first brick home in 1839. It took Hamilton, who had learned brick making from his father, over a year to make enough bricks. The Hamiltons raised seven children in this house before it was torn down in 1899.

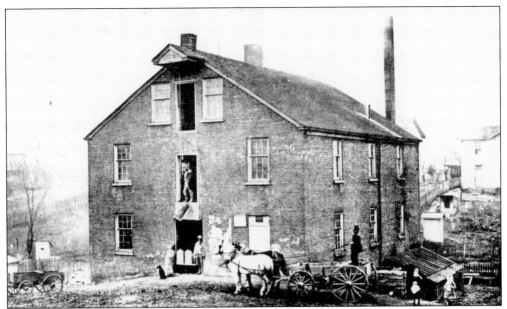

This brick gristmill was located on the south side of Penn Avenue near Coal Street. Brothers Edward and Moore Thompson built it in 1825 as a water mill powered by Nine Mile Run. It was later converted to a steam-powered mill owned and managed by Levi Ludwick from 1866 to 1887. Local farmers brought their grain to the mill to have it ground. The mill stood for over 100 years.

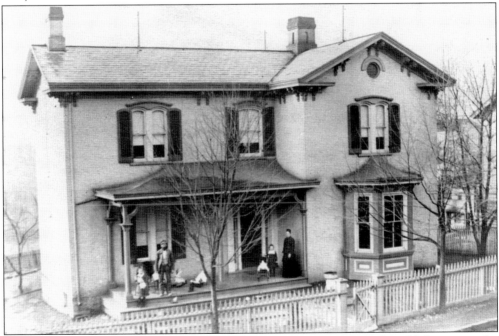

Levi Ludwick was a building contractor who built homes and commercial establishments in the area. After his marriage to Nancy Anderson, he built this house at 904 Penn Avenue in 1867. In 1866, he took over the ownership and management of the steam gristmill on the corner of Penn Avenue and Coal Street, in the same block as his home. The house was torn down in 1940.

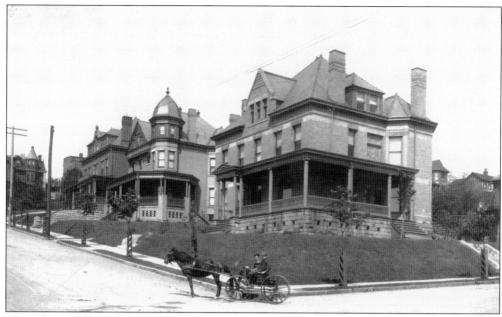

The Alfred William and Mary Boyd Duff home, still standing at 1200 Center Street at North Avenue, was built in 1893. Attorneys A. W. Duff and R. A. Balph represented the petitioners for the incorporation of Wilkinsburg borough in 1887. Duff was president of the First National Bank of Wilkinsburg and an Allegheny County Court judge. He died in 1925. Pictured in the wagon are the Duff children, William and Louise.

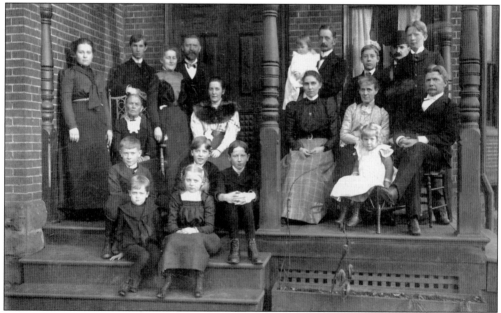

This Duff family portrait was taken on Thanksgiving Day 1899, at the home of James H. and Susan T. Duff, at 800 Wood Street. Alfred William Duff, Wilkinsburg's first borough solicitor, is standing, holding his baby daughter, Louise. His wife, Mary, is seated in front of him. Standing at the far right is 16-year-old James Henderson Duff, who later served as Pennsylvania attorney general (1943–1947), governor (1947–1951), and United States senator (1951–1957).

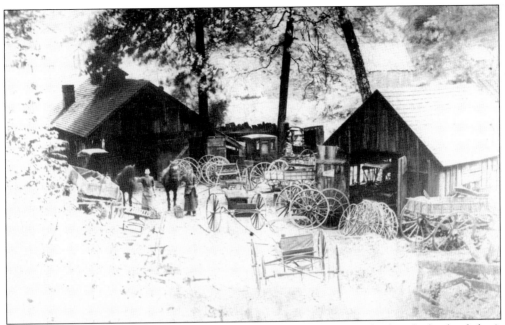

Harry W. Swisshelm moved to Wilkinsburg in 1889 at the age of 38. He had worked in his father's Monroeville blacksmith shop since age 12. Swisshelm's first carriage and wagon works is shown here at Penn Avenue and West Street. Later Swisshelm moved his business to the northwest corner of Penn Avenue at North Trenton Avenue where he and his sons added automobile painting and repairs. Swisshelm died in 1943.

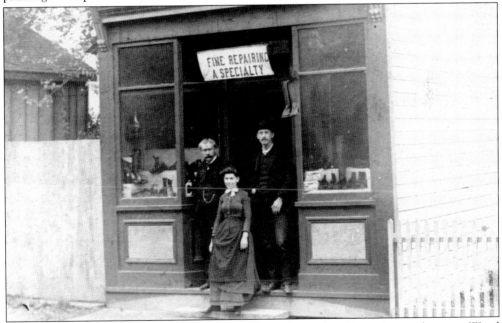

In the 1880s, William Cain's shoe and boot store was located on Penn Avenue between Wood and Hay Streets. At the rear of the store, Cain created a two-room home for himself, his invalid wife, two daughters, and a son. After the scarlet fever death of one daughter, followed by the death of his ailing wife, Cain closed his shop permanently.

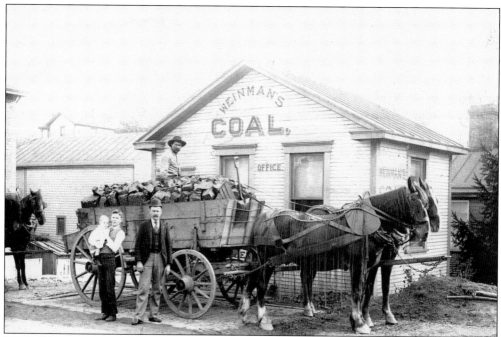

Jacob Weinman opened a coal mine at the end of Swissvale Avenue in 1871. The scales for weighing coal wagons are shown in this photograph of the Weinman's Coal office at Penn Avenue and Coal Street. Jacob's sons, Jacob Jr. and Joshua, later managed the business as Weinman Brothers. At one time, Jacob Sr. also owned the old turnpike and toll road east of Coal Street where the tollgate was located.

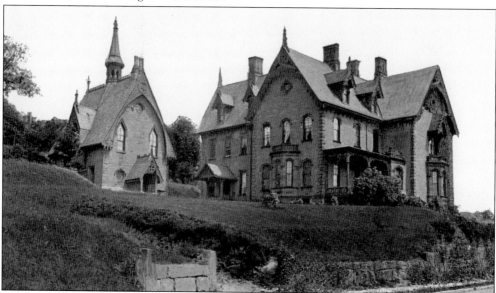

John F. Singer and Alexander Nimick owned a large iron-manufacturing business in Pittsburgh. About 1861, the partners bought, from James Kelly, large adjoining tracts of land north of Penn Avenue near Wood Street. In 1864, the Singers began to build this three-and-a-half-story stone Gothic-style mansion. The elaborate 18-room, four-bath Singer mansion was said to have cost an astonishing $75,000. Singer died in 1872 at age 57.

Two

GROWTH OF A BOROUGH

In 1789, Col. Dunning McNair purchased Africa, a 266-acre tract of land that later became part of Wilkinsburg. He did not sell a single lot until 1811. Patrick Green, a Revolutionary War veteran from Cumberland County, bought the first lot for $100. The lot had 66 feet of frontage on the Great Road and a depth of 264 feet. McNair sold only 33 lots to 15 buyers. Every deed required that $1 be paid yearly to the treasurer of a school or seminary. Meanwhile, McNair continued to acquire land.

The panic following the War of 1812 made it impossible for McNair to make the payments on his heavily mortgaged property. His mortgage, dated 1800, was assigned by the Pennsylvania Population Company to William Griffith of New Jersey. Griffith foreclosed by 1824, and 856 acres were deeded to him. McNair died in 1825.

James Kelly purchased the 856 acres McNair had held for $12,000 in October 1824. Kelly sold a number of single lots and some larger parcels while he continued to buy land. He also donated 10 acres to a school for deaf children, 5 acres to each of two homes for the aged, and a number of lots to various churches. When Kelly's financial difficulties began in 1875, he still held over 1,000 acres. By 1879, he owed over $300,000, and his land was sold at sheriff's sale to cover his debts. Kelly died in September 1882.

Agitation to create a borough began in the early 1880s by citizens who wanted the municipal services a local government could provide. Attorneys Rowland Armstrong Balph and Alfred William Duff presented a petition for incorporation signed by 229 residents. A grand jury reviewed and rejected this and later a second petition. Finally the third petition was successful, and on October 5, 1887, Wilkinsburg became a borough. Municipal improvements soon followed: paved streets, fire and police departments, electrical service, natural gas service, water and sewer systems, and telephone service. At incorporation in 1887, the borough had 800 residents. By 1892, the population had grown to 3,000.

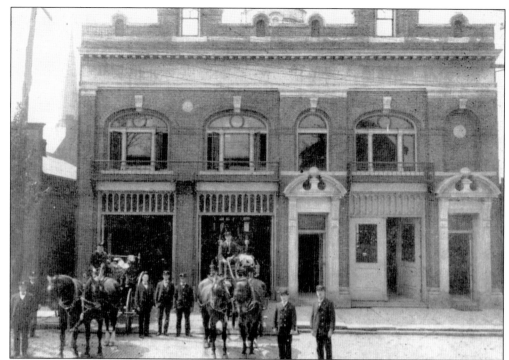

In 1903, a paid fire department replaced the volunteer department begun in December 1889. Shown here in front of the original municipal building at 608 Ross Avenue, the department headed by Capt. George Cromlish included 10 firemen and four horses. Three horses, Sam, Cap, and Steel, were named for councilmen while the fourth, Harry, was named for his driver, Harry Irwin.

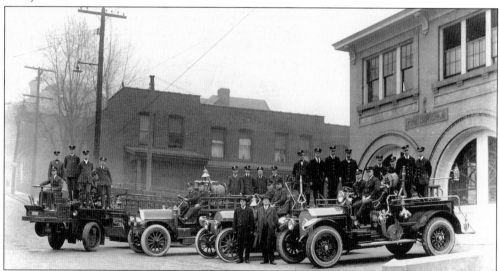

These fire engines in front of Fire Department No. 2 on Swissvale Avenue at Burns Street, about 1920, are, from left to right, a 1915 Christie ladder, a 1911 Knox, a 1912 American LaFrance, and a 1920 American LaFrance. This 1911 fire station used horse-drawn apparatus as well until 1915. The haylofts and feed bins were removed during remodeling in 1953. The Christie consisted of a two-wheeled motorized tractor pulling formerly horse-drawn equipment.

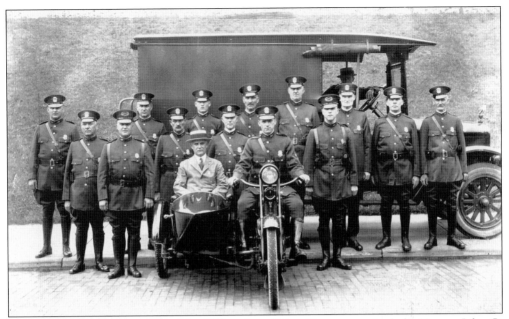

This official 1920s photograph of the Wilkinsburg Police Department includes Burgess John G. Miles, seated in the sidecar. John F. Dyer is on the motorcycle. The others are, from left to right, (first row) Chief Wallace Bishop, Jacob Fry, William M. Kelly, and Lt. Adam H. Fornof; (second row) John Bainbridge, Samuel Rankin, Charles Bainbridge, George Tucker, James A. Thomson, Robert M. Elwood, Sgt. Nelson A. Fulton, Walter Magee, and Joseph Courtley.

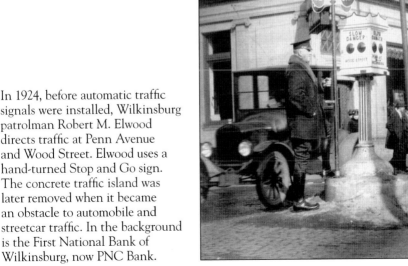

In 1924, before automatic traffic signals were installed, Wilkinsburg patrolman Robert M. Elwood directs traffic at Penn Avenue and Wood Street. Elwood uses a hand-turned Stop and Go sign. The concrete traffic island was later removed when it became an obstacle to automobile and streetcar traffic. In the background is the First National Bank of Wilkinsburg, now PNC Bank.

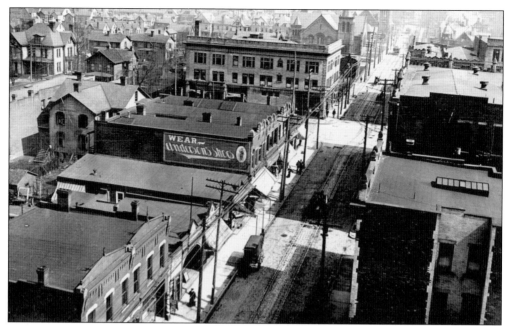

This view, looking north on Wood Street, shows the intersection with Penn Avenue about 1910. The Rowland Theater replaced the building in the left foreground in 1911. Among the businesses on the right is the Woolworth Company's five-and-ten. Farther up Wood Street on the left is the new (1899) First Presbyterian Church at Wallace Avenue, and at the top of the picture is the First United Presbyterian Church.

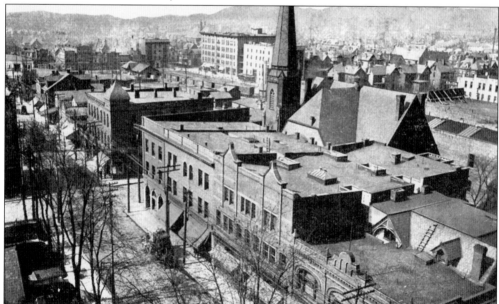

By 1900, the west side of Wood Street, shown here, was already developed. Private homes including doctors' offices lined the east side of Wood Street. The old (1866) First Presbyterian Church in the 600 block of South Avenue is at the center of the picture. The two large apartment buildings in the distance are Brinker's Hall and Annex on Hay Street. They were later known as the Colonial Apartments.

24

Real estate developer Leopold Vilsack erected Wilkinsburg's first "skyscraper" on Wood Street at Ross Avenue in 1908. He named the seven-story Carl Building after his youngest son. The post office was on the ground floor, which has housed many commercial establishments over the past century. The upper floors were offices for doctors and other professionals. Vilsack was also the founder and first president of the Pittsburgh Brewing Company.

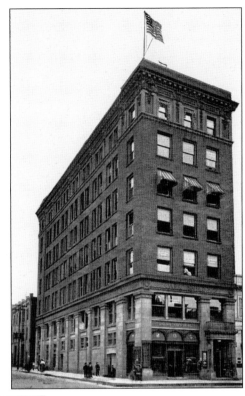

Make Wilkinsburg Safe and Clean for the Boys and Girls

·◆·

How to Vote November 5
LIQUOR BALLOT

Do you favor the granting of malt and brewed beverage retail licenses for consumption on premises where sold in the borough of Wilkinsburg	**YES**	
	NO	**X**
Do you favor the granting of liquor licenses for the sale of liquor in the borough of Wilkinsburg	**YES**	
	NO	**X**

VOTE EARLY

KEEP THIS A REAL HOME COMMUNITY
COMMUNITY BETTERMENT MOVEMENT

Wilkinsburg had been legally dry since 1870. After federal prohibition was repealed in 1933, Pennsylvania law made liquor sales a local option. The inability of Wilkinsburg authorities to cope with the disorder caused by the 50-odd licensed saloons in town brought the issue to the ballot. One of the local campaigning committees issued this advertisement. The dry vote won in November 1935—7,657 to 4,610—and Wilkinsburg remains dry today.

25

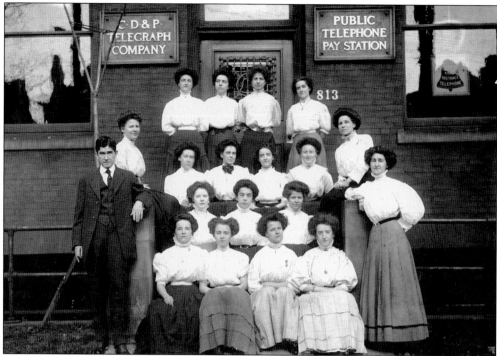

The Central District and Printing Telegraph Company, founded in 1889, moved to this new building at 813 South Avenue (today's Wilkinsburg Boys and Girls Club) in 1903. The staff included manager Frank McGrath and chief operator Vernie Marsh. The alley alongside the building became known as Telephone Way. In 1913, the company changed its name to Central District Telephone, and in 1918, it became part of the statewide Bell system.

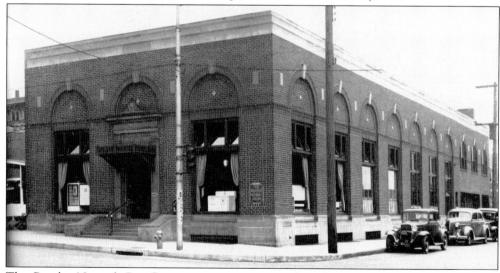

The Peoples Natural Gas Company was incorporated in June 1885, two years before the incorporation of Wilkinsburg. The company laid pipeline to Wilkinsburg from natural gas wells in Murrysville, 14 miles away. By 1937, Peoples was serving over 23,000 homes in the Wilkinsburg area, and the business office had moved to the southeast corner of Penn Avenue and Hay Street. Here customers could purchase appliances, make payments, and arrange for service.

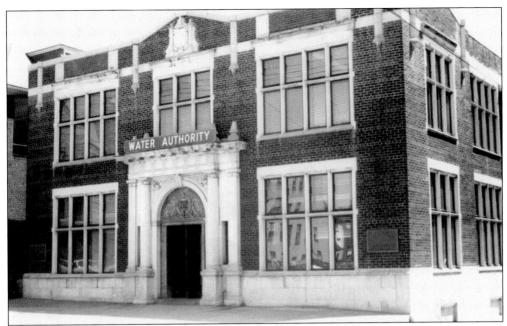

Water in pipes! The Pennsylvania Water Company was established in March 1887. By spring 1889, piped water was available. The water was pumped from the Allegheny River to sedimentation basins and filtered through sand beds at the Nadine Pumping and Filtration Plant in Penn Township. Wells, pumps, and cisterns were a thing of the past in Wilkinsburg. By 1922, the company had moved to this building at 712 South Avenue.

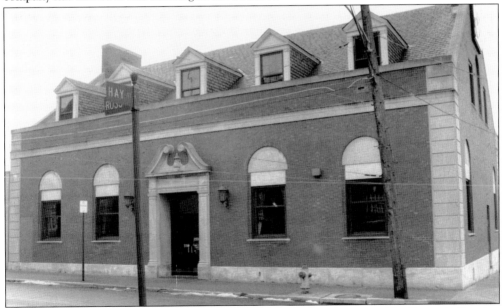

A United States post office was opened in this building on Ross Avenue at Hay Street in October 1936. It served Wilkinsburg, Forest Hills, Braddock Hills, and part of eastern Pittsburgh. The staff included a superintendent, an assistant, 14 clerks, 37 carriers, and a rural carrier. The building was later purchased by Rochez Brothers and is now owned by Allegheny East Mental Health and Mental Retardation Services.

Dr. Fulton R. Stotler, a 21-year-old graduate of Jefferson Medical College, opened his Penn Avenue office in May 1869. By October 1876, he had saved enough to study in Europe. He married a German citizen, returned, and built this home at 611 Penn Avenue. Dr. Stotler was physician to the deaf school and to the two homes for the aged on Rebecca and Swissvale Avenues. He retired in 1922.

Contractor Alexander Lohr built this 10-room Victorian at 616 South Avenue in the early 1890s. He also built the Lohr Building on Wood Street at South Avenue. After he and his wife, Caroline, died in the mid-1920s, Thomas and Clara Bonner lived there. Clara Bonner's tearoom, the Arcade, was at 714–718 Wood Street. David and Precious Parrott bought the home in the mid-1930s. Parrott's moving business was next door.

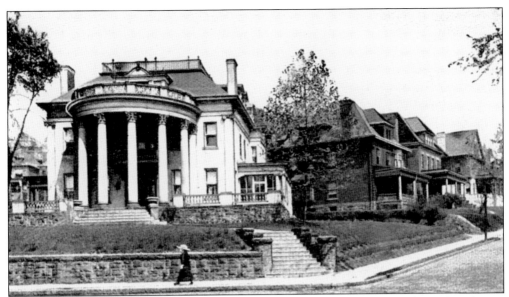

Roswell Yingling, a prosperous brick and coal dealer, and his wife, Marian, built this elegant home at 1300 Wood Street in late 1905. The land had been part of the 31-acre Singer estate. In December 1927, the mansion became the Wilkinsburg Private Hospital, operated by doctors William Johns, Louis Smith, and Harry Dilty. The hospital became a nursing home in 1945 and is the Gibbs Rest Home today.

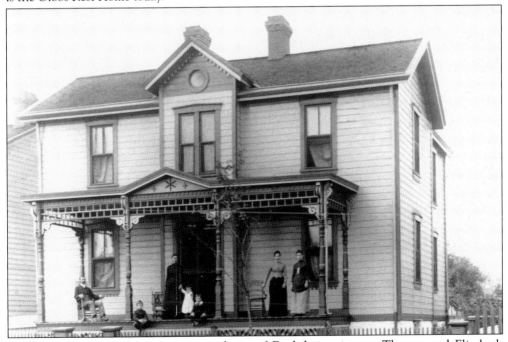

William Burgess, a brick contractor and son of English immigrants Thomas and Elizabeth Burgess, built the Reformed Presbyterian Church on South Avenue. William moved his parents' house to the back of their property on Alfred Street (now Trenton Avenue) and replaced it with this larger one. Here, in 1888, are William (left), wife Mary (standing) with son Harvey, sons Tom and William (seated), and daughters Margaret and Annie (right).

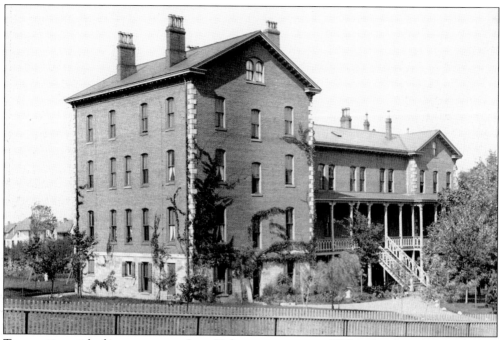

Two cousins with the same name, Jane Holmes, were among Wilkinsburg's early benefactors. One of them founded Sheltering Arms on land donated by James Kelly. The home opened its doors in 1872 as a suburban "refuge for unfortunate women and wayward girls" and later became the Home for Aged Protestant Men and Couples. It operates today as the Jane Holmes Residence and Gardens at 441 Swissvale Avenue.

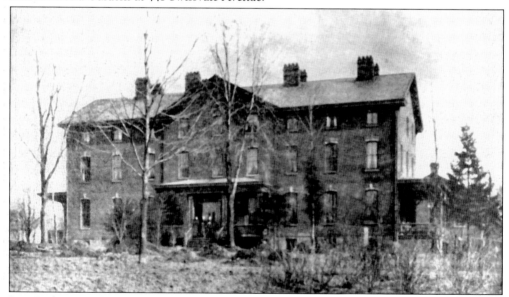

Jane Holmes's Baltimore-born cousin, "Baltimore" Jane Holmes, founded the Home for Aged Protestant Women in March 1871. The home at 900 Rebecca Avenue was built for $2,500 on land donated by James Kelly. In 1881 a 32-room annex was added. Residents assigned their income and assets to the home in exchange for "life care." Renamed the Rebecca Residence in 1984, it is now the Three Rivers Center for Independent Living.

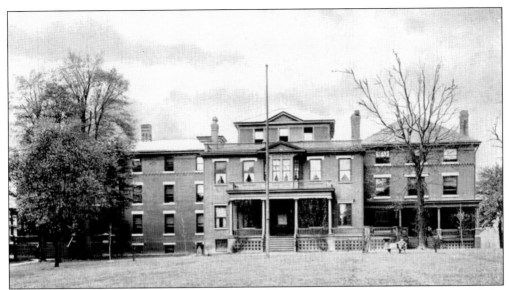

In June 1892, the United Presbyterian Women's Association of North America founded the United Presbyterian Home for Aged People. The association purchased the five-acre Bissell homestead (formerly the Woodwell and the Horback homestead) at 306 Penn Avenue. The home formed the center of the new facility, opened in September 1892. Over time, three wings and an annex for men were added. The home closed in 2000 and was later sold to Cornell Abraxas.

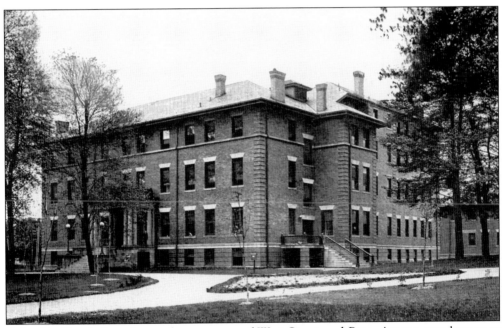

Columbia Hospital, at the southwest corner of West Street and Penn Avenue, was known as Memorial Hospital when the United Presbyterian Women's Association of North America opened it in June 1906. The hospital was located on the same five-acre site as the association's home for the aged. An east wing was added in 1907 for a school of nursing, then a fifth floor in 1912, and another wing in 1950.

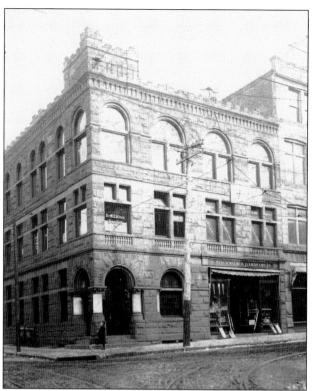

The First National Bank of Wilkinsburg opened in 1892 at 923 Penn Avenue (between Mill and Coal Streets). The bank rapidly outgrew that space and acquired a lot on Penn Avenue at Wood Street for this new building, which opened in 1894. Soon needing still more space, the bank bought and remodeled Walmer's Hardware (seen next door). The building has had several face-lifts over the century of its existence.

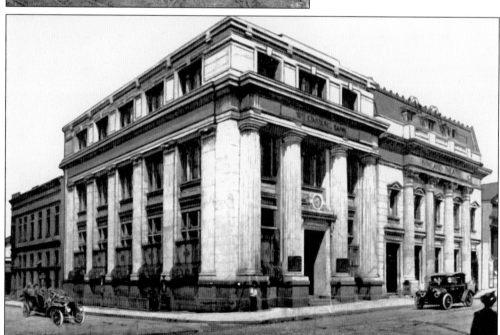

The Wilkinsburg Bank opened in June 1896 on a small lot at 901 Wood Street. Its first loan was for $1,000 to the Methodist Episcopal church. Acquiring more land and moving the old building (far left) to the back of the lot, the bank opened this new stone building on Wood Street at Ross Avenue in 1908. In 1911, the Rowland Theater (right) was built in a similar architectural style.

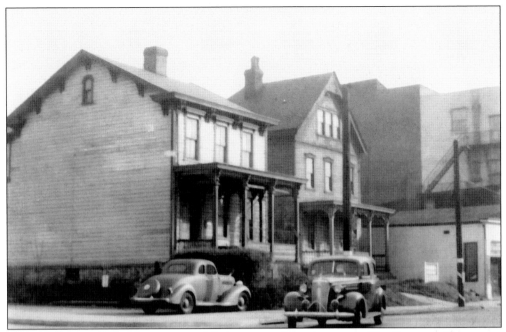

These homes are not there anymore. They were on Ross Avenue at Hay Street and were torn down in November 1938. In only 13 months, they were replaced by Wilkinsburg's new municipal building. Ross Avenue was a two-way street then. At the far right are the back walls of the Rowland Theater and Mellon Bank, now Citizens Bank.

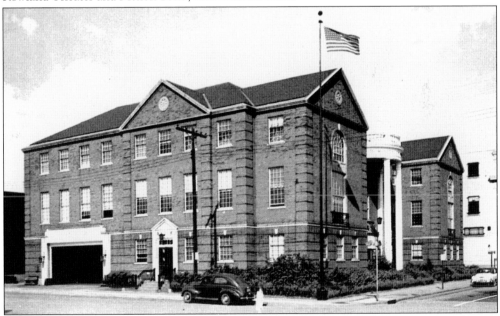

On January 1, 1940, an artillery salute and a parade of local officials, civic associations, and bands celebrated the dedication of Wilkinsburg's new $425,000 municipal building. Dedication of the flag and flagpole, gifts of the Elks lodge, was followed by speeches and tours of the building. Still the heart of local government, 605 Ross Avenue includes officials' offices, council chambers, police and fire departments, the public library, and an auditorium.

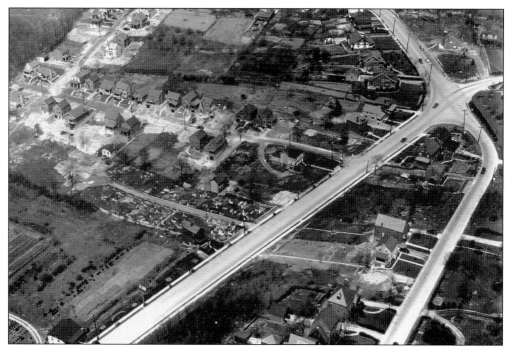

This 1938 aerial photograph shows the intersection of Laketon Road (lower left to upper right) and Graham Boulevard. The St. Nicholas Greek Orthodox Cemetery, developed in 1919, is in the center of the picture. Houses are being built on Doyle and Sampson Streets (the intersection at upper left). The side road (lower left) is the entrance to the Joseph Thomas Greenhouses, where the Douglas Plaza Apartments are today.

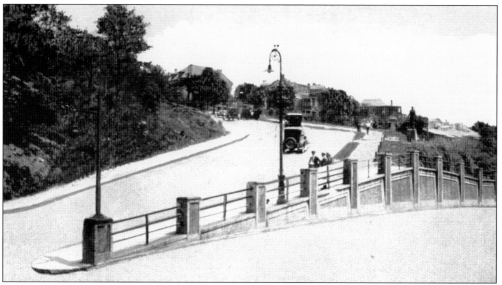

Penn Avenue travels eastward and uphill from Swissvale Avenue and then divides into the two roads shown here. The upper road, Penn Avenue, became known as the William Penn Highway (Route 22). By 1915, the lower road, now Ardmore Boulevard, was the Lincoln Highway (Route 30). The Abraham Lincoln statue was erected at this intersection in 1916. Wilkinsburg schoolchildren collected and donated pennies for the project.

Three

TEACHING THE CHILDREN

In Wilkinsburg's early years, all education was private. The first teacher in the village was Adam Turner, who taught in his log home near the present site of Turner School. James Graham, who came to Beulah Presbyterian Church as pastor in 1804, secured the teaching services of David Henderson. In 1819, Pastor Graham hired a young Irishman, Thomas Davison, to teach at Lime Hill School at the top of the Greensburg and Pittsburgh Turnpike just off Penn Avenue. In 1817, Col. Dunning McNair established a private school in his home, Dumpling Hall, for his own children and those of his friends. After James Kelly bought Dumpling Hall, he hired Napoleon Bonaparte Hatch to teach there. Mary Davis Horner, wife of squire John Horner, conducted a neighborhood school in her home.

Fifteen-year-old Jane Grey Cannon, who later married James Swisshelm, started a school in 1830 in her mother's log house on the Great Road (Penn Avenue). She "abolished corporal punishment entirely and was so successful that boys, ungovernable at home, were entirely tractable." The famous Wilkinsburg Academy, a private school more advanced than the common (public) school, was started in 1852. Elizabeth Duff Taylor started a school for younger children in her home in 1867. About 1870, Isabelle Johnston Wylie opened a private school mostly for girls on South Avenue. The Sisters of Charity opened the St. James Catholic School in 1886.

In 1840, Wilkinsburg adopted the Free Common School Act of 1834. James Kelly, one of the first school directors, furnished the brick and loaned the money for Wilkinsburg's first common school. The one-room redbrick structure, on the corner of Center Street and Wallace Avenue, served until 1850. A second two-room school was built on Center Street closer to North Avenue. Increasing enrollment made a third school necessary by 1875. Soon thereafter the school board had to rent the old Wilkinsburg Academy building. A fourth school—a modern fifteen-room, three-story brick building on Wallace Avenue—opened in September 1882. By 1887, Wilkinsburg's common school enrollment was nearly 400, a student population that grew tenfold over the next half century.

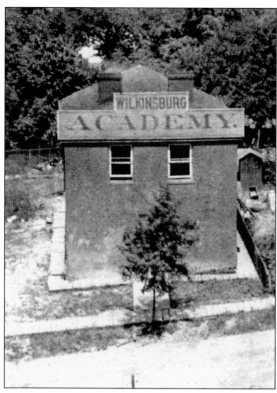

James Huston started the private, coeducational Wilkinsburg Academy in 1852. Tuition for a half-year term was $20. The academy moved to this new school building on Wallace Avenue at Center Street in 1856. After Huston's death, the Reverend John Hastings, pastor of Beulah Presbyterian Church, took control. Hastings's brother Fulton ran the school from about 1855 until it closed at the beginning of the Civil War in 1861.

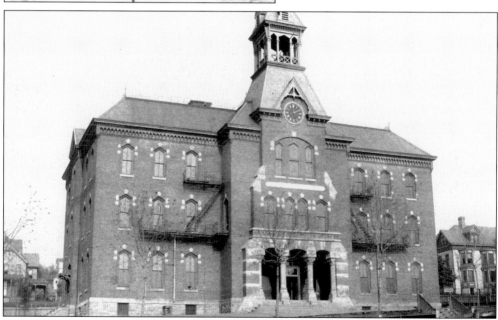

The school board purchased three lots on Wallace Avenue to build this modern three-story, 15-room school. Horner School, named for squire John Horner, opened in September 1882. The building was set on spacious grounds and had a 400-seat assembly hall. The heating, ventilation, and furnishings were first class. By 1885, the borough's only public school had eight grades. The school was completely destroyed by fire in 1890.

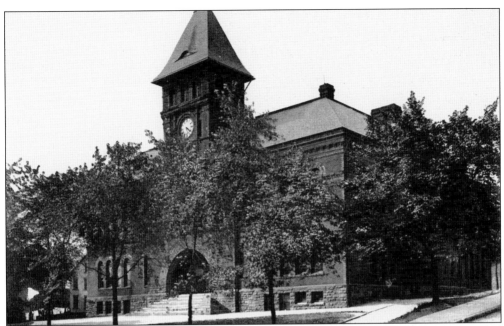

The original Horner School was destroyed by fire in early 1890. Wilkinsburg students attended school in several churches while the school shown here, a second 15-room Horner School, was built on the same site. In 1916, this school too was completely burned. In 1890, the borough was divided into three wards, and from then until 1912, school directors were elected by ward. Since 1912, school directors have been elected at-large.

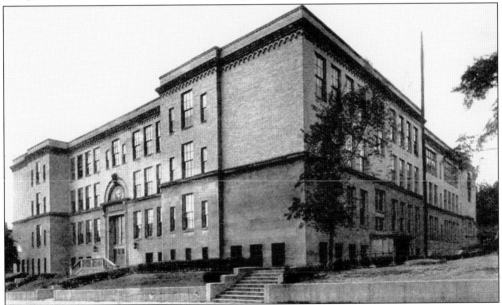

In January 1918, the Horner Junior High School was opened on the site of the Horner School destroyed by fire in 1916. This, the third Horner building, was closed in 1985 due to declining enrollment. Grades seven through nine were transferred to the high school. In 1990, the building was sold to Covenant Church of Pittsburgh, which remodeled the building for use as a community center, Hosanna House.

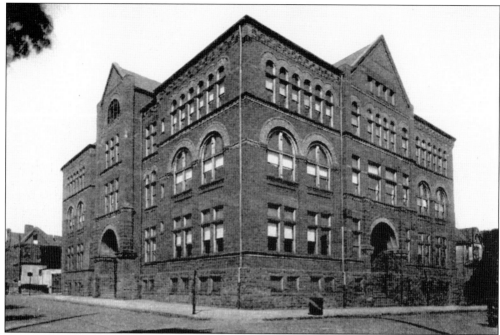

The three new schools erected in the 1890s were named after the community's early founders: Horner, McNair, and Kelly. Kelly School is pictured here at the corner of Pitt and McNair Streets. The third floor was added in 1893 to add five classrooms. In 1969, the school was torn down, and a new Kelly School was built on Kelly Avenue at Pitt Street.

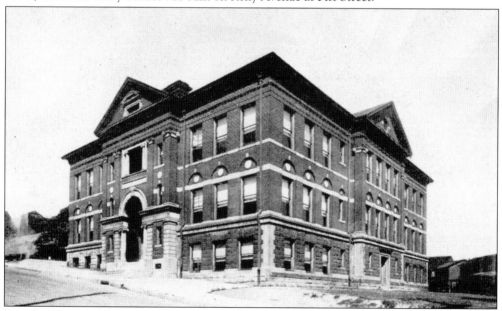

Semple School, on Swissvale Avenue at Laketon Road, was built in 1903. It was named for Dr. John Semple, a beloved member of the community who had died in 1901. About 1855, Semple built a spacious home on Penn Avenue, later the site of the Penn Lincoln Hotel. Semple School had 14 rooms for kindergarten through sixth grade. It was last used in 1974 and later torn down.

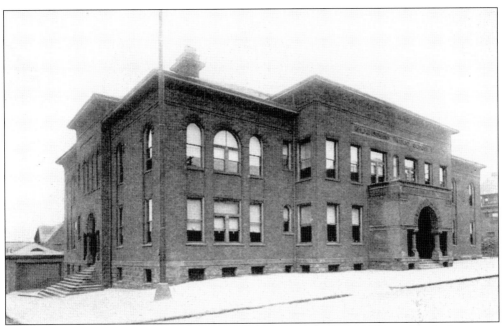

McNair School, named after Col. Dunning McNair, was built in 1895 on South Avenue at Center Street on land purchased from a Presbyterian congregation. In September 1899, the Carnegie Library of Braddock opened a branch in one of the school's classrooms. In 1920, a fresh-air school for about 16 children with anemia was opened in McNair. The school was demolished in 1950 and is now the site of the Ferguson playground.

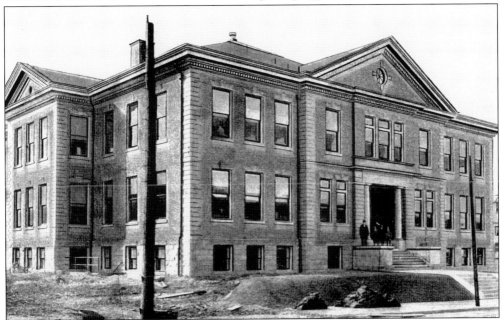

All but the first floor of the old Johnston School on Franklin Avenue at Ardmore Boulevard was destroyed by fire in 1920. The new Johnston School was built in 1922 by adding two stories to the old first floor. The land on which the school stands was once part of Gen. John Johnston's farm. It was donated by one of the general's grandsons, James L. Johnston.

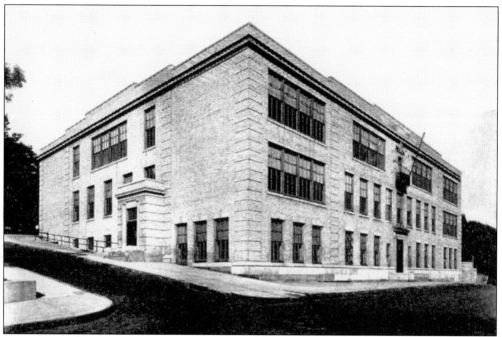

Allison School on Wallace Avenue at Mill Street was built in 1927 to relieve the overcrowding at Horner School next door. This elementary school was named after James L. Allison, a school district superintendent from 1902 to 1922. Allison School was closed in 1985, and the building was sold in September 1993.

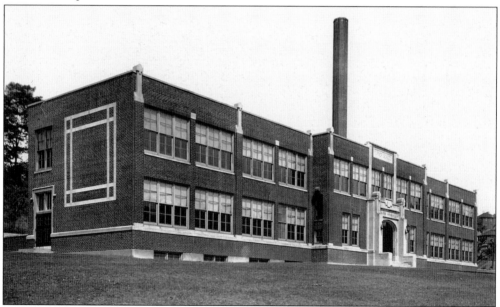

Turner School, for kindergarten through grade six, was built at 1833 Laketon Road in 1927. William M. Turner, who sold the land to the school district, asked that the school be named for his family. At the time, the Wilkinsburg School District also accepted students from the East Hills area of Pittsburgh under a contract with the Pittsburgh School District. Today Turner School includes half-day classes for prekindergarten students.

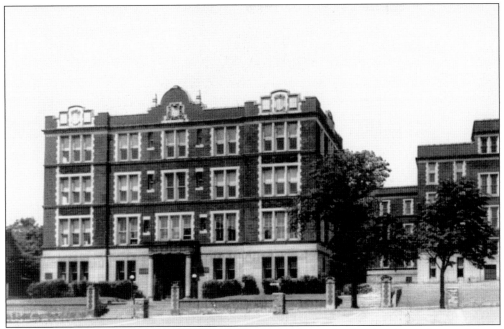

By 1908, a new building was needed to house the growing high school population. Voters approved a bond issue to build the high school seen on the left in this 1955 photograph. The building was dedicated on March 30, 1911. In 1912, the school district's total student population was 3,170. The annex seen on the right was built in 1929, adding classrooms, a larger auditorium, and a second gymnasium.

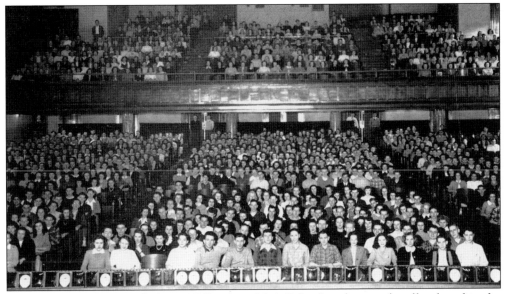

This mid-1940s photograph shows Wilkinsburg High School students and staff gathered in the school's new (1929) auditorium for 10:00 a.m. chapel. Principal William C. Graham started daily chapel in 1911, and the custom continued for over 50 years. Chapel included choir and organ music, a Bible reading, recitation of the Lord's Prayer, and the Pledge of Allegiance to the flag. During football season, Friday chapel ended with a pep rally.

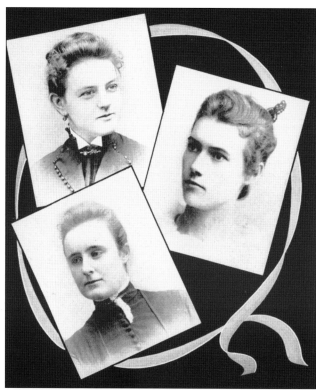

In 1887, the same year the borough was incorporated, these young women were the first graduating class of the Wilkinsburg School District. They are (clockwise from the top) Emily Munson, Alice Potter, and Clarissa Moffitt. The idea of a commencement ceremony was not introduced until 1893. Lacking an auditorium, the graduates gave a short program and received their diplomas at the Odd Fellows hall.

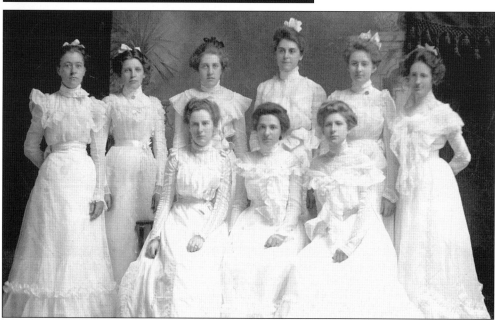

In May 1900, these nine young ladies graduated from Wilkinsburg High School. From left to right are (first row) Laura Armstrong Louis, Ella Richard Winter, and Nelle P. Maxwell; (second row) Josey Sperling Martin, Margaret Myers Trick, Margaret McCaffery Cargo, Ellen Vierheller Connor, Harriett Marshall Boyd, and Grace Elder Finley. Maxwell taught at Horner School for a number of years and was principal of Allison School from 1932 to 1948.

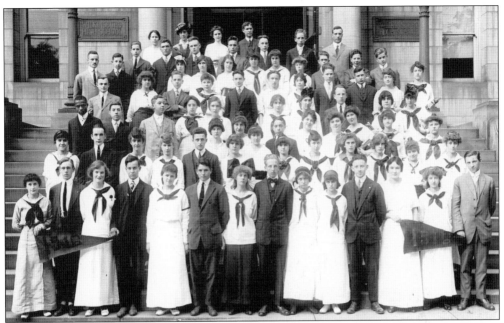

The high school occupied the first floor of Horner School until the 1890 fire. Over the next 19 years, high school classes were held in two churches, a commercial building, and in the elementary schools (Kelly, Horner, McNair, and Johnston). By the time the high school building was completed, over 403 students had graduated in the 24 years since 1887. This is a photograph of the graduating class of 1916.

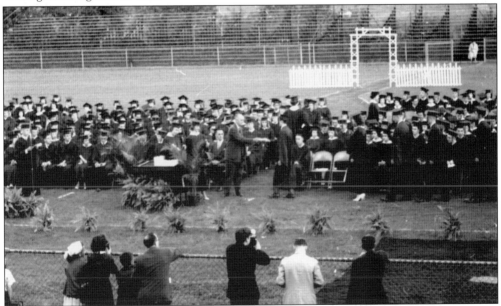

Wilkinsburg High School graduation ceremonies are normally held at Graham Field, weather permitting. This photograph shows the class of 1956 receiving its diplomas. Family and friends watched from the grandstand as the students filed in from the south side of the field and took their places facing the audience. In inclement weather, the graduation ceremony is held in the high school auditorium, which limits the number of guests.

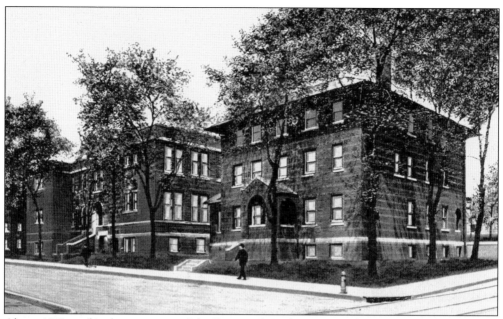

About 1912, under the pastorate of the Reverend Andrew A. Lambing, a noted educator and historian, St. James Parish built this school building (on the left) on Rebecca Avenue. The school was started by the Sisters of Charity of Greensburg in September 1886. By 1951, the building had a third story. A new wing was added to the school in 1962. The convent (right) is on Rebecca Avenue at Mulberry Street.

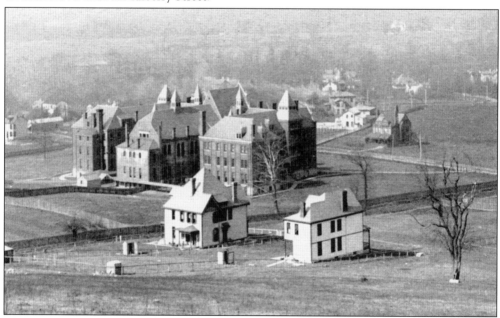

The school in this 1889 photograph was later named the Western Pennsylvania School for the Deaf. It was built on 10 acres of land donated by James Kelly in 1870. In December 1899, a fire in the boys' wing caused extensive damage. The school reopened in March 1900, and a new building was dedicated in May 1903. The two houses in the foreground are on Walnut Street in Wilkinsburg.

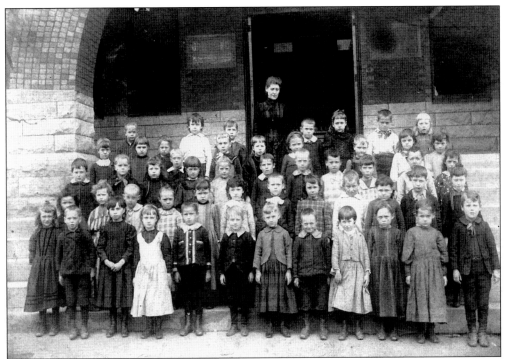

In the 1890s, group photographs like this one at Horner School were taken of every grade. Until the mid-1880s, public schooling in Wilkinsburg ended with the eighth grade. Beginning in 1885, students who completed the eighth grade were offered a one-year high school course. Over the next two decades, a second and then a third year of high school were added. The first four-year high school class graduated in 1907.

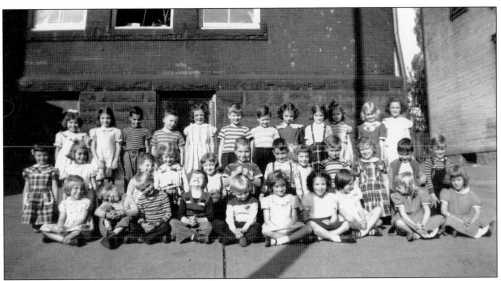

The educational adventure was just beginning in 1949 for these 34 Kelly School first-graders. When the borough was incorporated in 1887, the Wilkinsburg schools had 680 students. Twenty-five years later, in 1912, there were 3,170 students. In 1937, there were 5,528 students. By 1962, the number of students had started to decline; there were 5,327 students.

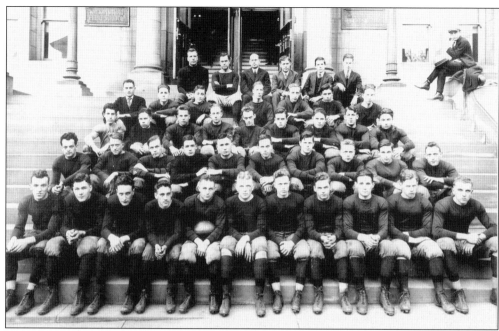

In 1916, the year Graham Field was dedicated, the Wilkinsburg High School football team won the Western Pennsylvania Interscholastic Athletic League championship for the third time. It had won in 1914 and 1915 as well. The team also won the 1916 Syracuse Trophy. The coach was William G. Marshall. The 1922 and 1957 teams also won league championships.

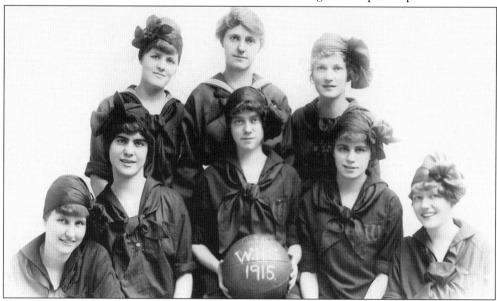

The W girls were the Wilkinsburg High School girls' basketball team of 1915. Under the leadership of coach Marion C. Cross (second row, center), the team's annual gymnasium exhibition showcased tactics, calisthenics, and folk dancing. At the end of the season, team members Caroline Bauman, Esplen Birrel, Vera Felker, Helen Hardman, Dorothy Moore, Mary Norman, and Frances Wylie were awarded sweaters and letters. The team luncheon was followed by a theater party.

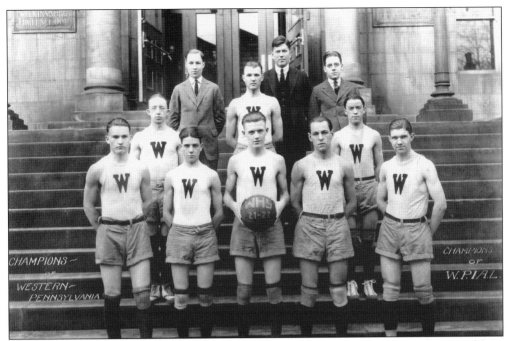

The boys' basketball team of 1921–1922 won the Western Pennsylvania Interscholastic Athletic League championship with a record of 20 wins and four losses. The regional league championships played a big part in the borough's history. In 1922, the high school teams won the league titles in both football and basketball, a feat not equaled since. The basketball state championship went to Harrisburg Tech by a score of 25-14.

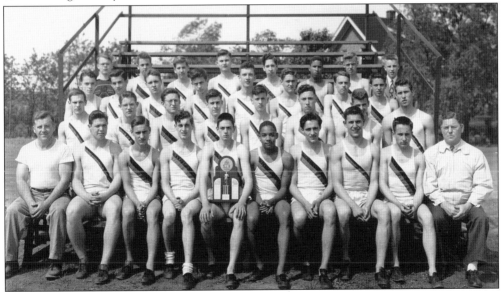

Wilkinsburg High School's spring 1948 track team earned a first place in the Western Pennsylvania Interscholastic Athletic League with George Alcott (holding the trophy) as the outstanding participant. Alcott was also very successful in the Pennsylvania Interscholastic Athletic Association, as was Thomas Stephens (on Alcott's right). Seen in the first row are trainer Thomas Donaldson (far left) and coach John Browning (far right).

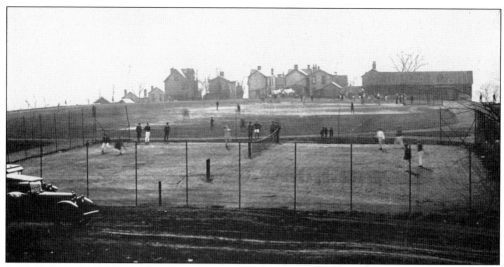

By 1917, the new athletic field at the site of the former Johnston farm on Penn Avenue and Weinman Street (now Princeton Boulevard) was known as Graham Field in honor of William C. Graham. Graham was the high school principal from 1903 to 1928 and school district superintendent from 1929 to 1941. This view is of the tennis courts that were initially part of the field.

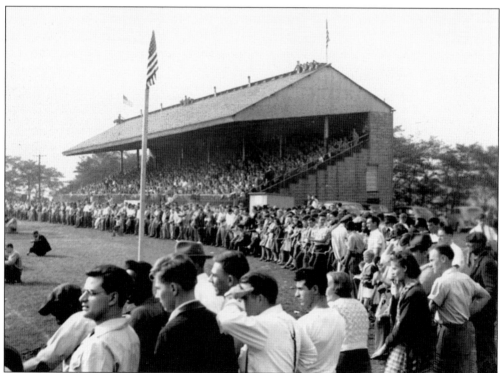

The new seven-acre, $24,500 Wilkinsburg Athletic Field (now Graham Field) opened on Saturday, October 7, 1916, with a football game against Homestead High School. Until then, football, baseball, and track events had been held at DC and AC Park on Hay Street and North Avenue. The covered grandstand was added in 1929. This crowd is watching a Saturday afternoon football game in 1939. The Wilkinsburg Tigers still play football here.

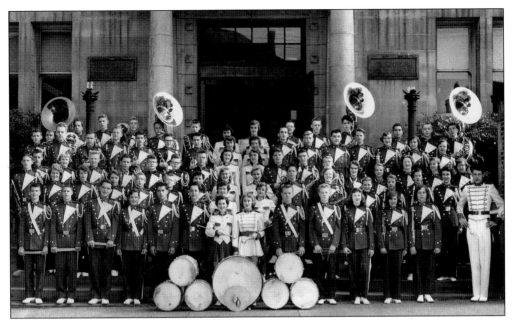

With "Sound of the Drums," the 1955 Wilkinsburg High School band members marched across the field to put on a precision halftime show at all the football games. They performed at the Friday afternoon pep rallies, the spring festival, Halloween and Memorial Day parades, and, of course, the second year of the Kiwanis Club of Wilkinsburg Marching Band Festival in September 1954. Richard Camp was the band director.

The words to "For You High," Wilkinsburg High School's alma mater, were written in 1915 by freshman Halsey Burdette Gilmour; the music is from the 1914 musical *Chin-Chin*. Stricken with scarlet fever, Gilmour left school for a while and did not graduate. He joined the army and served in France during World War I. He died of pneumonia in 1930. Gilmour's song became a symbol of Wilkinsburg High School.

49

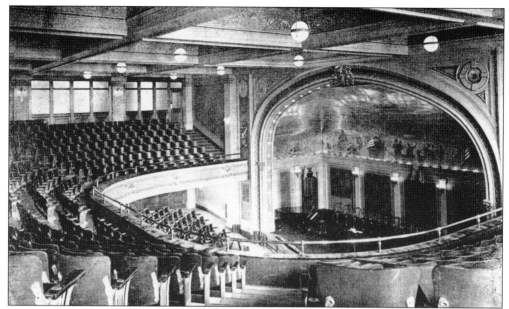

The Wilkinsburg High School building was dedicated on March 30, 1911. The first two floors had seven classrooms each. The third floor had lecture halls; physics and chemistry laboratories; and a kitchen, dining room, and banquet hall for the domestic science department. The new school, including the land, furniture, equipment, and concrete walks, cost $368,000. On May 25, 1911, a commencement for 49 students was held in this 1,100-seat auditorium.

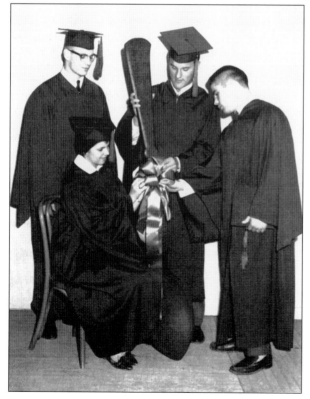

The spoon tradition reigned at Wilkinsburg High School for over 75 years. In 1901, the graduating senior class initiated the custom of bestowing upon the junior class a six-foot-long wooden spoon. The spoon symbolized the responsibility for upholding the school ideals of loyalty, honor, leadership, and scholarship. Here the officers of the class of 1960 examine the spoon, which was usually kept in a glass-enclosed case in the library.

Four

CITY OF CHURCHES

The area's first church was formed in 1784 at Bullock Pens (Beulah Presbyterian Church), two miles east of the village of Wilkinsburg. It became known as the Pitt Township Church. Beulah Presbyterian, as it was renamed in 1804, built a brick church in 1837.

In 1832, Methodism came to Wilkinsburg. James Kelly donated land in 1843 for the first Methodist church. He did the same for the Reformed Presbyterians in 1845, the Presbyterians in 1869, and the Catholics around 1868. Kelly also provided land to the Trinity Reformed Church in 1871 and St. Stephen's Protestant Episcopal Church. The village had become "church-minded," and by the 1900s, it was known as the "Holy City."

"Old Jimmy" Kelly and the churches campaigned for temperance until an 1870 state law made Wilkins Township dry. After federal prohibition was repealed in 1933, Pennsylvania law made the decision a local one. The churches played a significant role in the defeat of the 1935 referendum on the granting of liquor licenses in the borough. Wilkinsburg remains dry today.

In the early days, churches were located within walking distance of their parishioners. Several denominations, therefore, organized more than one church in the town. Many of the churches were large, some having over 1,000 members. The first burgess (mayor), elected in 1888, was a clergyman, the Reverend Charles W. Smith. He was the editor of the *Methodist Christian Advocate* and later a bishop of the Methodist Episcopal Church.

In 1912, there were 21 Christian churches in Wilkinsburg. By 1940, there were 25 houses of worship, including a synagogue organized in 1936. A council of churches was organized in the 1920s. The central and enduring influence of the churches shaped much of Wilkinsburg's community life for over 150 years. Until the 1950s, a sign on Penn Avenue near Trenton Avenue welcomed travelers to the "City of Churches."

Methodism in Wilkinsburg began in 1832 as part of the Braddock Field circuit. The 24-member Wilkinsburg Methodist Episcopal Church was organized in 1843. The congregation built Wilkinsburg's first church on a Wallace Avenue lot donated by James Kelly. This is the original one-room building with additions completed in 1878. In 1892, the growing congregation sold the property to the Baptists and moved to its present site on South Avenue.

In 1845, the Reformed Presbyterian Church (the Covenanters) erected this building on South Avenue at Center Street. James Kelly donated the site and attended the church until his death in 1882. The property included a stream, Nine Mile Run, and a cemetery. The cemetery was abandoned in the early 1890s, and the remains were moved elsewhere. The building was torn down in 1892 and a new church erected in the same year.

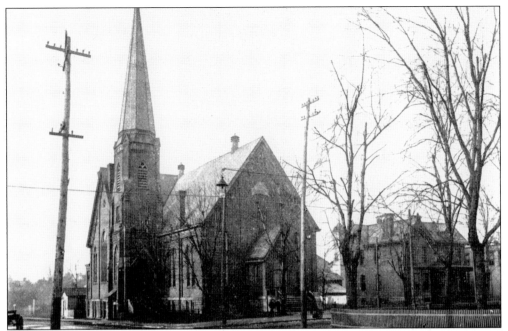

The First Presbyterian Church was organized in 1866. A church was built in 1869 on Wood Street at South Avenue, on land donated by James Kelly. The church is pictured here with the east wing that was added in 1887. The congregation relocated in 1901. The east wing was removed, and the land on which it stood was sold to commercial developers. The original building later became the Christian Church of Wilkinsburg.

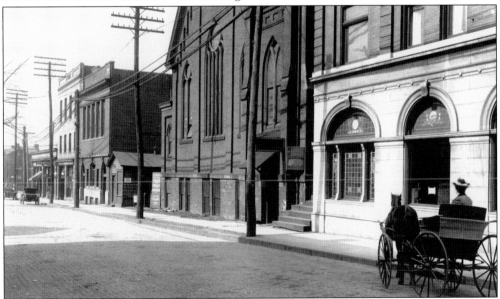

This church on South Avenue was the First Presbyterian Church from 1869 to 1901. The First Christian Church of Wilkinsburg acquired the building in 1901 and worshipped there until the church was destroyed by fire in 1915. This photograph was taken in 1914. The woman in the buggy is parked along the South Avenue side of the Central Bank, at the northwest corner of Wood Street.

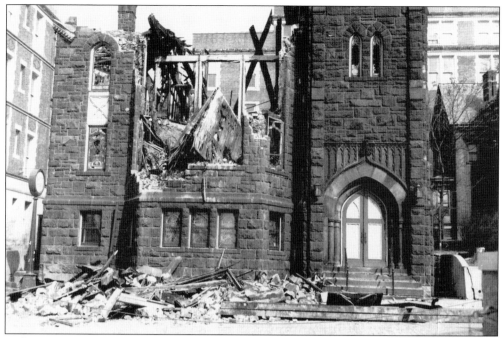

A disastrous fire in February 1955 destroyed the Wilkinsburg Baptist Church on the northwest corner of Center Street and Wallace Avenue. Flames broke out in the furnace room of the 1906 stone and brick structure. Plans were immediately underway for a new sanctuary, a three-story educational building, a chapel, and a courtyard for open-air vesper services. The cornerstone of the old church rests in the altar of the new church.

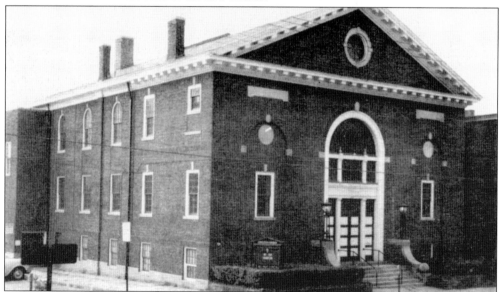

The Christian Church of Wilkinsburg began as a Bible school in November 1900 with about 90 members. The church purchased and remodeled the former First Presbyterian building on South Avenue near Wood Street. That building was destroyed by fire in January 1915. By October 1916, the congregation had moved into this church on Wallace Avenue across from Wilkinsburg High School. It is a member church of the Disciples of Christ.

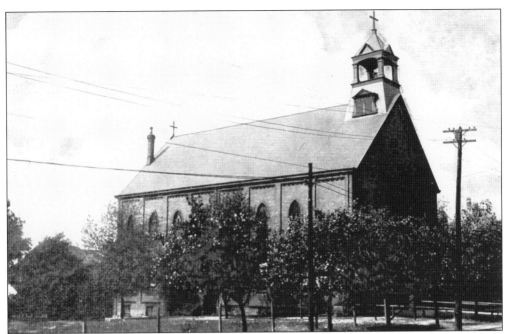

The first St. James Catholic Church was a frame structure erected in 1869. On Christmas Eve 1888, the church was destroyed by fire. The brick church and school shown here was dedicated in December 1889. A new St. James Catholic Church was built in 1929. The old church served as part of the school until it was torn down in 1961. A new 10-classroom wing replaced it in 1962.

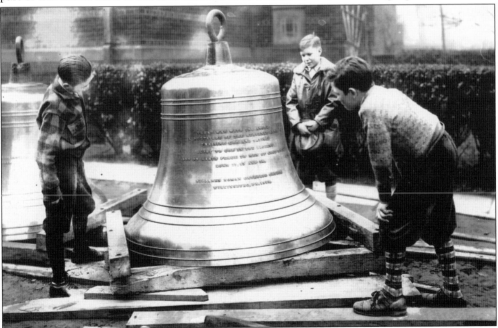

Three youths observe the delivery of two of the four tolling bells for the new (1929) St. James Catholic Church on Franklin Avenue at Mulberry Street. The stone church was dedicated in August 1930. The carillon has 20 other bells and can be heard over most of the town. It is one of the largest in western Pennsylvania. The parish priest then was the Reverend Stephen A. Walsh.

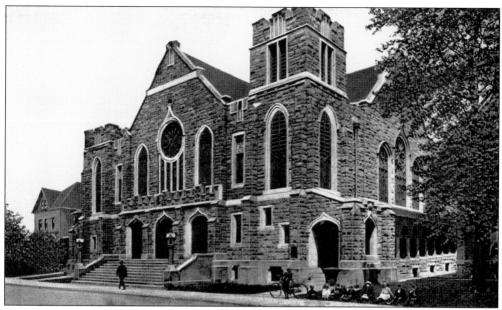

The cornerstone for a new South Avenue United Methodist Church was laid in 1907 following a previous fire. In 1909, the church at 733 South Avenue, between Wood Street and Center Street, was dedicated. In 1918 (after this photograph was taken), a cross was erected on top of the church building, and a flagpole was added. During its first 60 years, South Avenue was mother church to at least six other Methodist churches.

Ross Avenue Methodist Episcopal Church was organized out of South Avenue United Methodist in 1905. The new church on Ross and Swissvale Avenues, shown here, was completed in 1906. In 1927, the borough widened Swissvale Avenue, and the church building was moved back from the street. In 1965, James Street Methodist merged with Ross Avenue. Ross Avenue rejoined the South Avenue congregation in 1989. Today this building is Deliverance Baptist Church.

Methodists in Wilkinsburg's third ward had to cross dangerous railroad tracks to worship at the South Avenue church. They needed a church on the west side of town. In 1895, the Methodist Church Union donated the land for the Mifflin Avenue United Methodist Church. The 70-member congregation built a brick mission chapel for $6,200. Additions made in 1911 included classroom space, an auditorium, and an enhanced worship area.

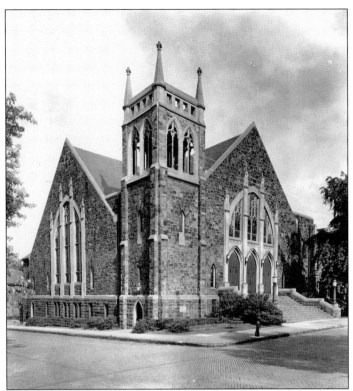

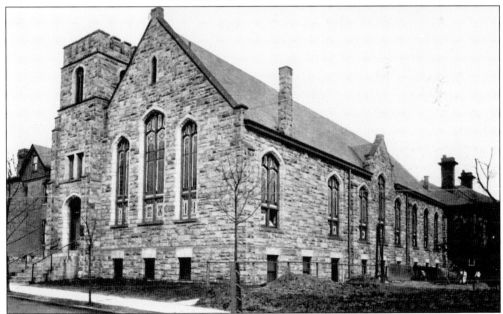

Church mergers often lead to a new name for the combined congregation. Mulberry United Presbyterian Church is an example. It was organized as the Second Presbyterian Church in October 1903. The congregation held its first service at this church on Mulberry Street in 1905. Additions were completed in 1912 and 1929. Second Presbyterian later merged with Northwood Presbyterian, forming Mulberry United Presbyterian.

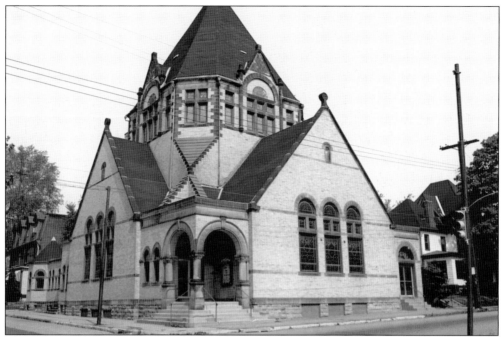

Trinity United Church of Christ, known as Trinity Reformed Church, was organized in January 1870. A chapel was built on Rebecca Avenue at Coal Street on a 66-foot lot donated by James Kelly. In 1897, the chapel was replaced by the church shown here. Andrew Carnegie gave the church a Mohler pipe organ. Trinity disbanded in the 1990s, and the building now serves the New Birth Family Worship Center.

Mount Calvary Baptist Church was organized on Penn Avenue at Coal Street in 1922. In 1923, the congregation moved to 1036 Penn Avenue, the building in the middle of this 1940s photograph. Next door at 1034 Penn Avenue was the Yee Wee Chinese Laundry, one of 14 Chinese laundries in Wilkinsburg in 1926. In 1965, the congregation purchased the former James Street Methodist Church at James Street and Swissvale Avenue.

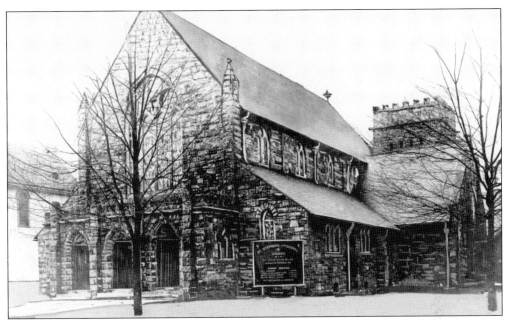

The first building for St. Stephen's Protestant Episcopal Mission was a small frame chapel on Pitt Street. The first service, for the children, was held in the chapel on Christmas Day 1882. In 1903, the construction of this larger church was started. A parish house replaced the chapel in 1931. Memorial stained-glass windows were added beginning in 1929, and in 1952, the west transept was converted to the Memorial Chapel.

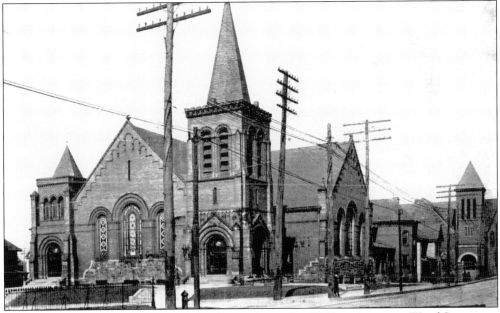

The First Presbyterian Church of Wilkinsburg, relocated to Wallace Avenue at Wood Street, was completed in June 1901. In 1954, an education building was added on adjacent land along Wood Street. In September 1984, the church closed. The Covenant Church of Pittsburgh purchased the church building, and the Prince Hall Masonic Order purchased the education building. In the background is the First United Presbyterian Church built in 1892.

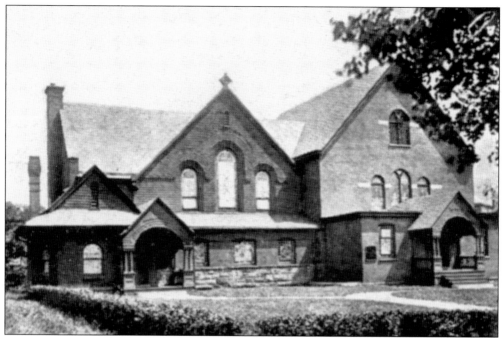

The Second United Presbyterian Church was organized in Lohr's Hall in June 1891. Services were held there until this church building on Hay Street at Biddle Avenue was completed in January 1895. The growing congregation soon remodeled the church and rededicated it in 1902. By 1914, the growing congregation had begun building a new church on the same site. The building was dedicated in 1916.

This temporary canvas "tabernacle" was erected in a borough park at the corner of Todd Street and Lamar Avenue in December 1914. It served the congregation of the Second United Presbyterian Church for two years while its new church building was under construction. The tabernacle, which had a kitchen and a large seating capacity, was also used for community events, including the Grade-Crossing Elimination Banquet in 1916.

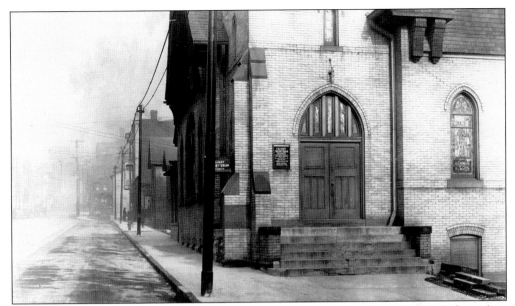

The Calvary Presbyterian Church was organized in May 1902. This church, dedicated in November 1905, stood at the northeast corner of Swissvale and Hill Avenues. The church was demolished when Swissvale Avenue was widened in 1927. The cornerstone for a new church building was laid in October 1928, and the church was completed a year later. The church is now known as the Covenant Fellowship Reformed Presbyterian Church.

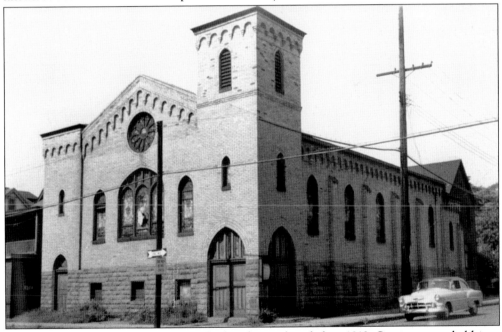

St. Mark African Methodist Episcopal Church was founded in 1912. Services were held in a storeroom on Montier Street and later in a Glenn Street home. In 1918, the members built their church foundation on a lot at the corner of Glenn and Montier Streets. They added a roof and worshipped there for 10 years. In 1929, this church was finally completed using materials from the razing of Calvary Presbyterian.

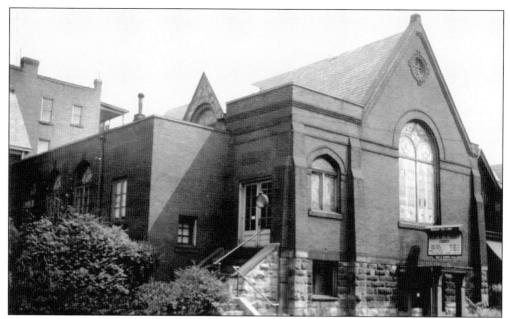

St. Paul's Lutheran built this church on Ross Avenue at Center Street in 1901. When St. Paul's merged with Calvary Lutheran in 1919, the YWCA bought the building and added a recreation room and a cafeteria. By 1946, the YWCA had moved to the former Pennwood Club, and the building became the Wesleyan Methodist Church, pictured here in 1950. It is now the St. Mark African Methodist Episcopal Zion Church.

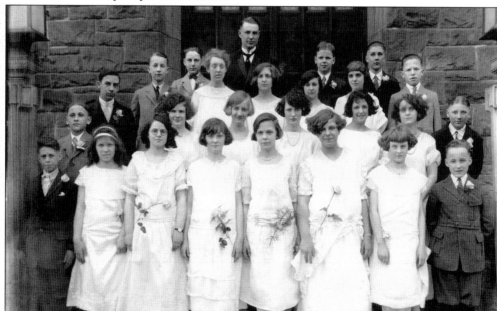

The Calvary Lutheran Church was established in 1896. In December 1919, Wilkinsburg's two Lutheran congregations, St. Paul's and Calvary, joined together to form the Calvary Evangelical Lutheran Church at the northwest corner of Center Street and South Avenue. Calvary Evangelical's April 1924 confirmation class is pictured here at the church's front door. The Pittsburgh Urban Christian School currently owns the former Calvary Evangelical complex.

Five

AVENUES OF COMMERCE

The Greensburg and Pittsburgh Turnpike, formerly called the Great Road, was the east–west road through Pitt Township in the late 1700s. By 1825, the Pike boasted such craftsmen as miller, carpenter, wagon maker, blacksmith, butcher, chair maker, carpet weaver, bag weaver, physician, and tavern keeper. A post office was established in 1840. Farming was usually conducted on a small scale, chiefly to supply the needs of the family. Most of the land was covered with large timber.

As described in *Harris' General Business Directory, 1841*,

> Wilkinsburgh is pleasantly situated near the Pennsylvania turnpike leading to Greensburgh, Chambersburgh and Philadelphia; the Northern Turnpike leading to Blairsville, Huntington and Harrisburgh intersects this, near this place. . . . Wilkinsburgh is becoming one of the most beautiful and desirable locations for country seats in our neighborhood. . . . There is much travel through this place, especially in winter when other transportation being closed, the freights between Baltimore, Philadelphia and Pittsburgh are carried by wagons. . . . There are two hotels, two merchants, a post office, a church, a school house, and several industrious mechanics in the place. A large quantity of lime is made in this vicinity.

The directory then listed 22 businesses and prominent people. The village of "Wilkinsburgh" had fewer than 100 residents.

In December 1852, the railroad came through the village, and commerce changed almost overnight. Residences on Main Street became places of business. Coal mining had started in the early 1800s. By 1873, the Hampton Mine had its own railroad spur running from the main line near Walnut Street, across Ardmore Boulevard to the mine's tipple near present-day Franklin Avenue and Princeton Boulevard. A railroad station stood on Wood Street at Rebecca Avenue from 1860 to 1915. The streetcar arrived in Wilkinsburg in the late 1890s. In 1880, there were 3,000 residents; by 1910, there were 19,000. All the streets were paved with brick by 1900. The community had many small commercial centers, including one on Trenton Avenue. In 1926, there were about 75 corner grocery stores. There were national and regional chain stores too. Yes, there was a Main Street in Wilkinsburg.

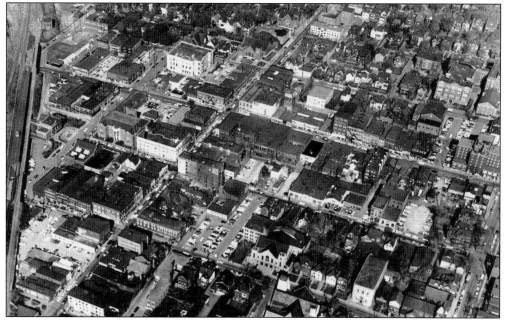

This 1958 aerial photograph of Wilkinsburg's business district was taken for the chamber of commerce. The Pennsylvania Railroad right-of-way runs along the left edge of the photograph. On the lower right is Center Street, intersecting Penn Avenue at the right edge of the picture. Penn Avenue runs from that intersection across town to the railroad underpass. The long street running from bottom left to top center is Wood Street.

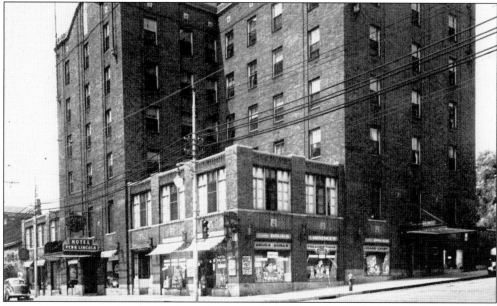

Two major routes to Pittsburgh from the east, the William Penn Highway and the Lincoln Highway, merge in Wilkinsburg. A group of citizens thought Wilkinsburg an ideal site for a first-class hotel. So, in the 1920s, they formed the Wilkinsburg Hotel Company to build the Penn Lincoln Hotel. At the hotel's grand opening on June 1, 1927, visitors beheld a modern fire-safe, six-story building with 150 guest rooms.

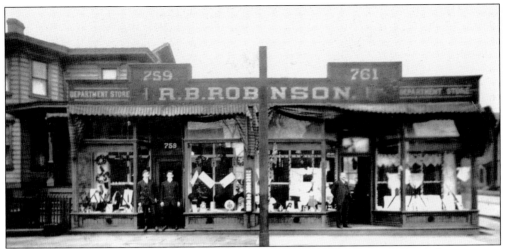

Richard Bradley Robinson's dry goods and notions store stood at 759–761 Penn Avenue near the northwest corner of Penn and Center Street. Robinson had moved to Wilkinsburg in 1877 after his marriage to Rachel Calderwood. The Robinsons had six children. In later years, Rachel Robinson was the first woman elected school director. Richard operated his department store for 20 years.

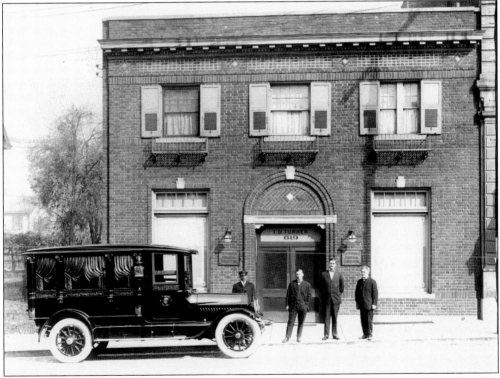

In 1860, Thomas D. Turner Sr. and his brother William established a general merchandise business. In 1881, the brothers dissolved this partnership so that William Turner could continue the general store while Thomas D. Turner opened an undertaking and livery business. T. D. Turner's Livery Stable began on Penn Avenue just east of Wood Street. This 1920s photograph shows the business at its newer location at 619 Penn Avenue.

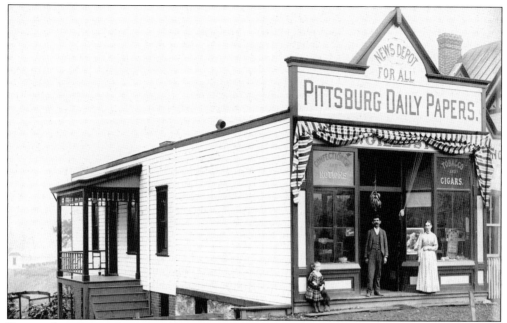

During the 1890s, Edgar D. Gillespie, shown here with his wife, Alexnia, and their daughter, opened this confectionery at 624 Rebecca Avenue, opposite the Wilkinsburg railroad station. Newspapers of the day did not offer home delivery, so "Pittsburg Daily Papers" is the shop's main advertisement. Pittsburg is spelled without an *h* because from 1891 to 1911 the United States Geographic Board required cities to drop the *h* from their names.

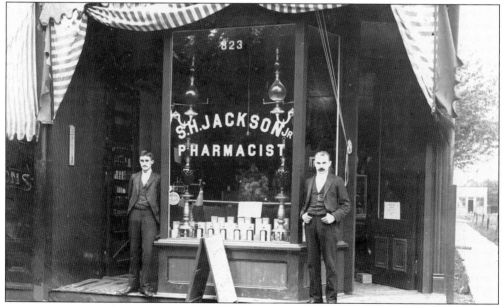

In 1897, Samuel H. Jackson Jr. owned and operated this pharmacy on the southwest corner of Wood Street and Ross Avenue. Jackson was the first president of the Group for Historical Research on Wilkinsburg Village and Environs 1788–1888. The group published *Annals of Old Wilkinsburg and Vicinity* in 1940. From 1911 to sometime in the 1950s, the Bukes Grill, owned by Speros and Helen Bukes, was at this location.

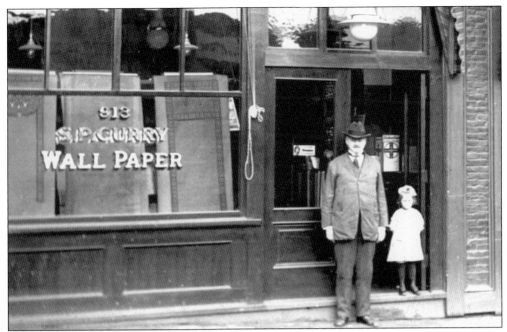

Samuel P. Curry opened this wallpaper and paint store at 913 Penn Avenue in the early 1900s. The little girl with him is his granddaughter Margaret S. Stiffler, who became an art teacher in Wilkinsburg schools. Curry moved his business to 734 Penn Avenue in the 1920s. He became involved in real estate and was a building contractor, erecting many houses in Wilkinsburg.

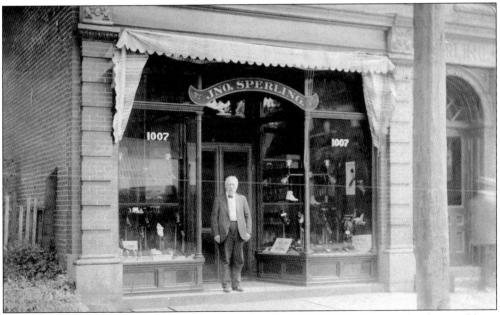

John and Philomena Sperling came to Wilkinsburg in 1866. Sperling opened a shoe and boot store on Penn Avenue, later moving to 913 Wood Street. About 1903, he built this apartment building at 1007–1013 Penn Avenue. His store was on the first floor, where Valley Sales and Service, a locksmith, is today. One of the Sperlings' 12 children was Charles F. Sperling, the borough's civil engineer for over 50 years.

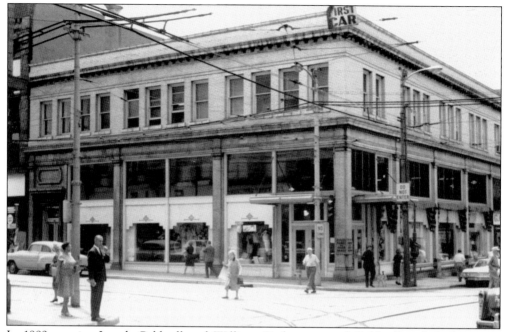

In 1889, cousins Joseph Caldwell and William Graham opened Caldwell and Graham Dry Goods at 812 Penn Avenue. By 1907, the store was located near the corner of Penn Avenue and Wood Street, next door to Woolworth's. When a 1907 fire led Woolworth's to relocate farther south on Wood Street, Caldwell and Graham purchased the corner site, rebuilt it, and ran a thriving business there for more than 60 years.

Caldwell and Graham Dry Goods, first established in 1889, opened this store at the southeast corner of Penn Avenue at Wood Street in 1908. It carried the finest of dry goods. Many customers watched in fascination as little metal containers on tracks sped their cash from the counter to a central cashier and returned with their change. As times changed, pneumatic tubes carrying cylindrical containers replaced the track system.

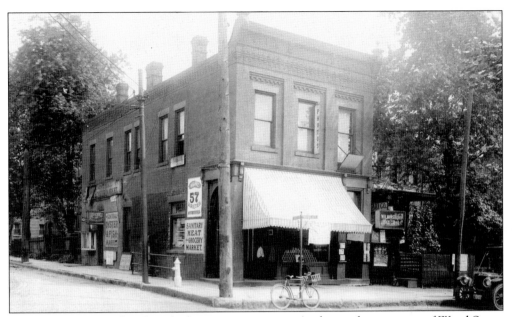

For over 50 years, Wilkinsburg had many corner stores. At the southeast corner of Wood Street and Franklin Avenue in 1914 stood the Sanitary Meat and Grocery Market. It advertised Heinz 57 Varieties. Clara H. Williams, 1 of the town's 3 women doctors out of a total of 48, had her office at the same address. Next door to Sanitary Meat was the headquarters of the Wilkinsburg Taxicab Company.

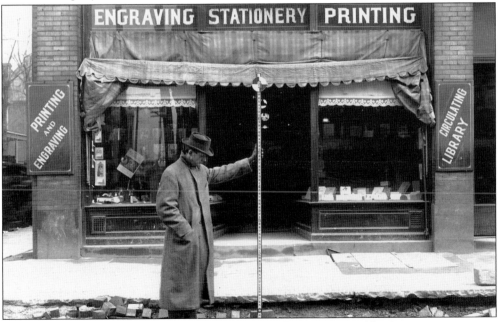

Wilkinsburg's "Office Depot" in this 1914 photograph is E. M. McClain's stationery store at 724 Wood Street at South Avenue. Harrison J. Hays, stationers, was a subsequent proprietor here. The man with the surveyor's rod is part of a surveying team involved in the lowering of Wood Street. Wood Street was lowered to allow passage under the railroad overpass being built at the intersection of Wood Street and Rebecca Avenue.

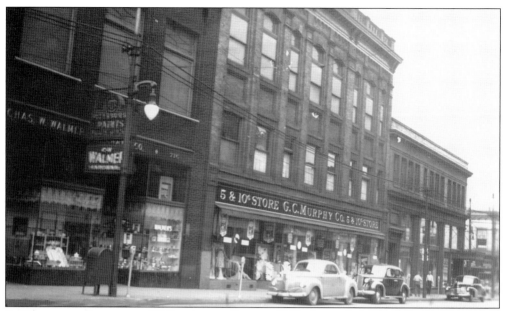

Parking meters first came to Wilkinsburg in January 1940, the week the new municipal building was dedicated. Crates containing the parts for the 300 automatic parking meters arrived at the traffic department of the police station. The penny-nickel meters were installed on Wood Street from Franklin Avenue to Wallace Avenue and on Penn Avenue from the railroad overpass to Mill Street.

The Charles W. Walmer Hardware Company was established in 1900 at 703 Penn Avenue. In 1922, the firm moved to this 716–718 Penn Avenue store. It was one of the finest and best-equipped retail hardware stores in Pennsylvania. The window displays were outstanding. On Walmer's east side was the Great Atlantic and Pacific Tea Company, a grocery store. On the west was G. C. Murphy's 5 and 10¢ store.

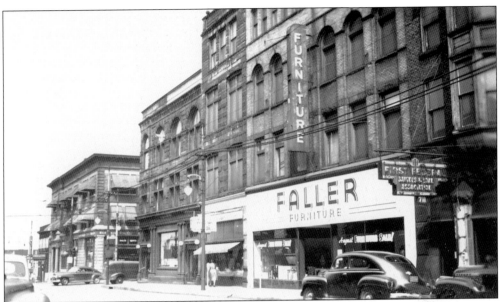

In 1924, Faller Furniture took over the Puffinburg Furniture Company at 707–709 Penn Avenue. Faller was in business at this location for over 50 years. This store was the fourth; the first was in Wilmerding in 1890. Other businesses in this 1940s photograph are the First National Bank at Wilkinsburg and the Federal Bake Shop (left of Faller) and First Federal Savings and Loan Association of Wilkinsburg (far right).

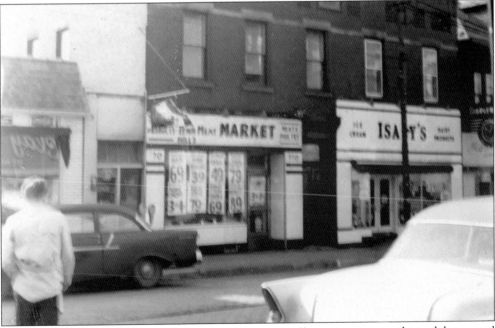

Isaly's was a familiar sight in Wilkinsburg. It meant Skyscraper cones, chipped ham, and Klondike ice-cream bars. A Klondike with a pink center got you another Klondike free. There was an Isaly's at 915 Wood Street from 1931 to 1970. This Isaly's, at 766 Penn Avenue from 1936 to 1980, is in the building once owned by George Fornof, who sold fresh and smoked meats in the 1890s.

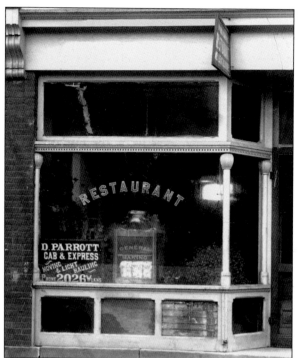

This 1915 photograph shows the small restaurant at 710 Rebecca Avenue that provided meals for workmen during the raising of the Pennsylvania Railroad tracks. The eating place sign reads "Workingman's Restaurant—Meals at all hours." A sign in the window advertises "D. Parrott Cab & Express—Moving & Light Hauling—Phone 2026 Wlkns."

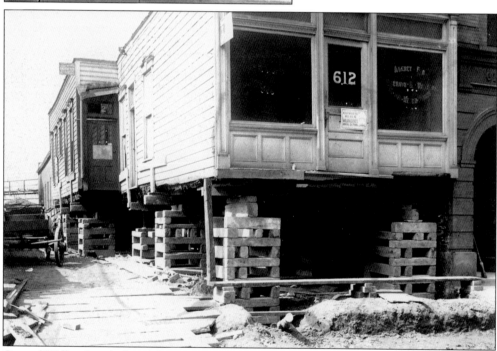

One of Wilkinsburg's first African American businessmen was David Parrott, a well-known resident. His moving company had four small green and white trucks. The slogan painted on the side of his trucks read, "Here Comes Parrott the Moving Man, He'll Move Your Things the Best He Can." This 1915 photograph shows his company office at 612 South Avenue being lowered as part of the construction of the Pennsylvania Railroad overpass.

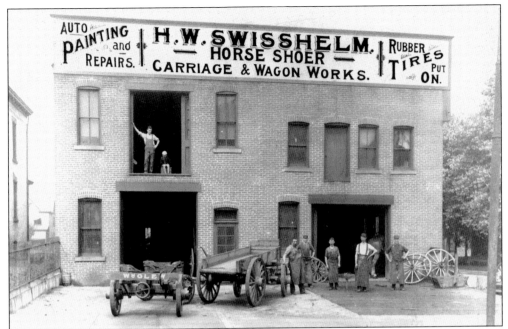

Harry W. Swisshelm did business in Wilkinsburg for over 50 years. At first he worked as a horseshoer, later as a carriage and wagon maker. As times changed, he and his sons added automobile repair at this shop on Penn Avenue at Trenton Avenue. After Swisshelm died in 1943, his daughter and three sons continued in the business. The Forbes Metropolitan Hospital was later built on this site.

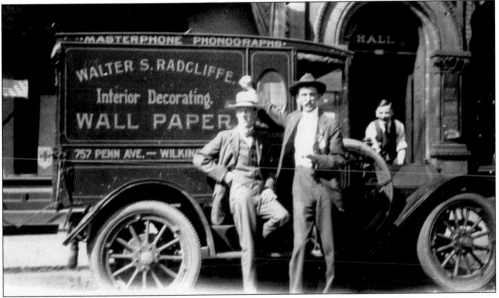

In 1905, William Radcliffe moved his wallpaper store from Pittsburgh to 735 Penn Avenue in Wilkinsburg. He offered picture framing and interior decorating. By 1916, the business was being operated by his son Walter S. Radcliffe. Around 1945, the business was moved to 761 Penn Avenue. The business and the building were later sold to C. J. Suske, who still uses the name W. S. Radcliffe Company.

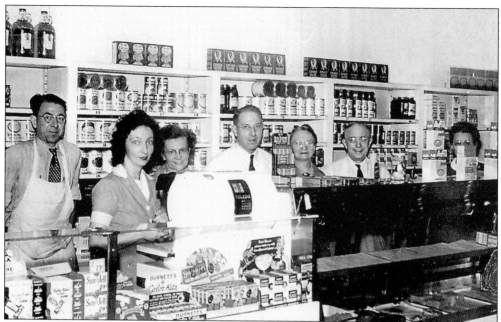

After selling butter and eggs door-to-door by horse and buggy, Edward R. Kregar opened a store in the 800 block of Wood Street about 1898. In 1908, he moved to this store at 900 Wood Street. For over 50 years, Kregars sold its famous nut bread and the best brands of foods, including Lady Baltimore cakes. During World War II, customers often lined up for blocks to buy butter.

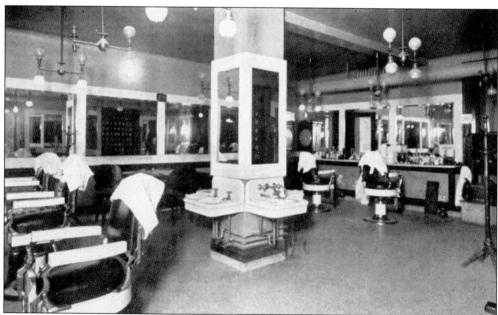

"A neat hair cut counts biggest in connection with dress. Five expert workmen." That was the advertisement for the Wilkinsburg Bank Barber Shop owned by Samuel T. Zener. Zener began barbering in Wilkinsburg in 1893 at 909 Wood Street. Later he moved to this shop at 621 Ross Avenue in the basement of the Wilkinsburg Bank building (now Citizens Bank). By 1939, there were over 30 barbershops in Wilkinsburg.

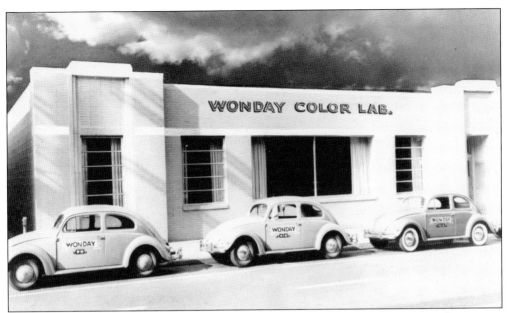

Michael J. Koch founded the Wonday Film Service at 615 South Avenue in 1919. In an expansion of the business in October 1941, Wonday moved its film-processing department to this site on Ross Avenue, where the original Wilkinsburg Municipal Building once stood. At the time, Wonday was developing film for over 400 dealers. Today Richard (Rick) J. Muzzey runs the company at 615 South Avenue.

At the time of the borough's 50th anniversary in 1937, there were four Van's Markets in the region. Charles A. Sander founded the business in Wilkinsburg in 1895 at 916–918 Penn Avenue near Coal Street, in front of the old grist mill. His son Herbert L. Sander Sr. expanded the business to include this store at 720 Penn Avenue. Van's provided home delivery.

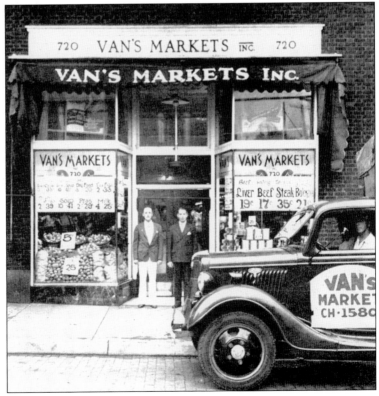

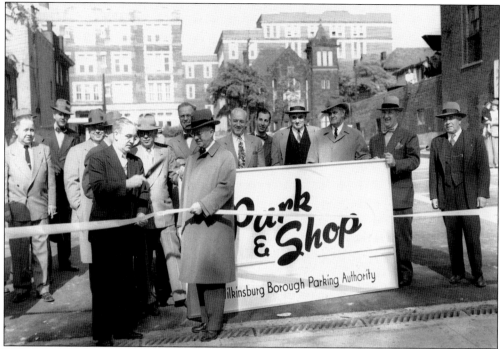

Wilkinsburg borough officials developed the Park and Shop concept in the early 1950s. They created the Wilkinsburg Borough Parking Authority, which purchased land for parking lots. Community merchants funded the parking by purchasing parking tokens from the chamber of commerce and giving them to customers. The first parking lot, seen above, was alongside the Penn Lincoln Hotel. In the background are the Wilkinsburg High School and the Baptist church.

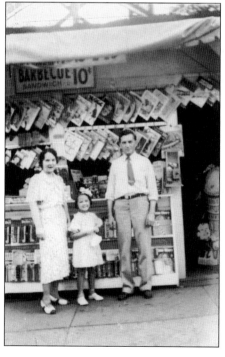

In 1935, Bill and Marie Topper opened a newspaper and magazine shop at 924 Penn Avenue near Coal Street. They sold a variety of items, including barbecue sandwiches and hot dogs for 10¢. During World War II, the Toppers kept their newsstand open 24 hours a day. They are shown here with their daughter Kay. When the Toppers died in 1955, the shop closed.

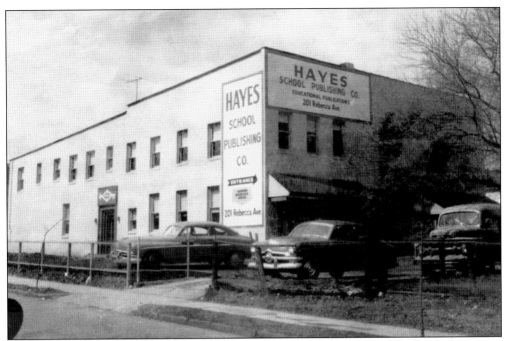

Clair Hayes Sr. and his wife, Ruth McClelland Hayes, started Hayes School Publishing Company in their Biddle Avenue home in 1925. In 1961, they moved into this building at 201 Rebecca Avenue and then in 1964 to the Hanlon and Wilson Company building at 321 Pennwood Avenue. Today the company has dealers in all 50 states and several overseas. Its school supplies are sold by mail order.

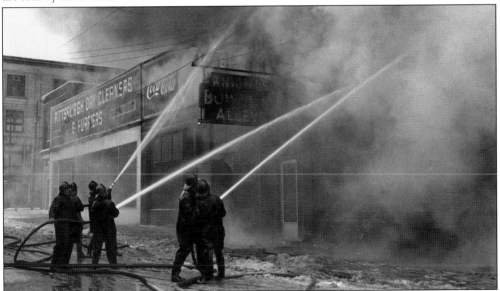

In November 1958, this fire of unknown origin destroyed Knight's Bowling Alleys and Pittsburgh Dry Cleaners on Wood Street. Both businesses rebuilt, and the dry cleaner is still in business. Wilkinsburg firefighters battled a number of damaging blazes over the years, including St. James Catholic Church in 1888, First United Presbyterian Church in 1895, Western Pennsylvania School for the Deaf in 1899, and T. D. Turner's Livery Stable in 1907.

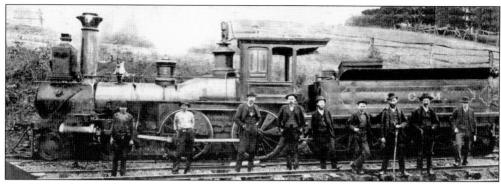

The Hampton Coal Company was opened on the George Johnston farm during the 1870s. Coal was brought out of the mine by mule carts, then lowered 500 feet downhill to the tipple by a cable incline. Hampton operated this railroad to haul coal from the tipple, near present-day Franklin Avenue at Princeton Boulevard, to a transfer site in Edgewood close to the Pennsylvania Railroad main line.

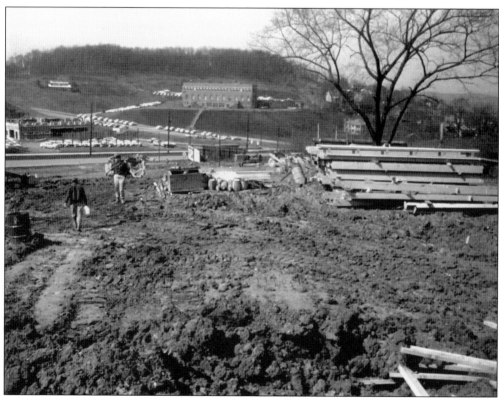

In December 1957, Television City, parent company of WTAE-TV, broke ground for the station's 12-acre site at 400 Ardmore Boulevard. By March 1958, construction had begun. Regular broadcasting began on Sunday, September 14, 1958. The announcers were Paul Shannon, Nick Perry, and Del Taylor. In the background are the Aiken (later Bendik) Oldsmobile dealership (on the left) and the Westinghouse Educational Center on Brinton Road.

Six

TRAINS, TROLLEYS, AND AUTOMOBILES

Over the last 250 years, the Great Road, the Pike, Main Street, and finally Penn Avenue were among the names for the east–west road through Wilkinsburg. Packhorses were used before 1800. In 1805, a stagecoach line was started. In 1816, wooden Conestoga wagons brought 5,800 wagoneers and thousands of draft animals. Wilkinsburg's first train rumbled through the village in 1852. The streetcars arrived in the early 1890s. Two brothers, both doctors, bought the first horseless carriage in Allegheny County in 1898. The main road was paved with bricks by 1900, and every automobile manufactured was available for purchase on Penn Avenue.

Two of Pennsylvania's great highways merged on Penn Avenue. In the 1920s, the northern route across the state was the William Penn Highway (Route 22). The early Lincoln Highway (Route 30) took the southern route. Rail and streetcar transportation contributed to Wilkinsburg's growth from 4,662 in 1890, 11,886 in 1900, 18,924 in 1920, and 24,403 in 1930 to over 30,000 in 1940.

The raising of the railroad tracks in 1916 was a significant event for Wilkinsburg. Since 1852, all the tracks had been at street level. Accidents were frequent and caused many serious injuries and deaths. The April 1902 *Automobile Magazine* described the Wilkinsburg railroad crossing:

> There are ten tracks to be crossed, almost a continuous passing of trains, some of them express trains going at a very high speed, no gates and only infrequently a watchman. The track crossings are extremely rough, making it necessary to run slowly over them if one is to avoid chancing a breakdown directly upon the railroad. The tracks curve in both directions from the crossing and there are usually several freight cars massed on the unused outer ones, which very thoroughly limit even what small view there is.

No wonder the town marked the elimination of its rail crossings with a huge celebration, capped by the dedication of its magnificent new railroad station and a statue of Abraham Lincoln. Truly Wilkinsburg had become a "Gateway to the West," attracting many people who made the community their home.

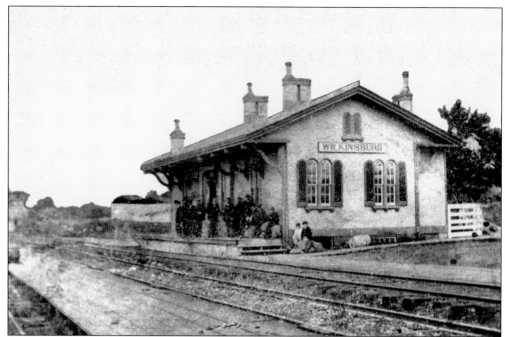

The Pennsylvania Railroad tracks into Wilkinsburg were completed in December 1852. The two-track roadbed ran nearly north and south across the western part of the village, and for years to come, the railroad ran at street grade level. James Kelly sold the wooden railroad ties to the railroad. The station depot shown here, built about 1860, was on Wood Street. In 1883, the station burned to the ground.

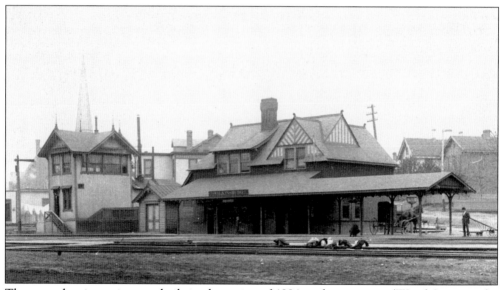

The second train station was built in the spring of 1884 at the same site (Wood Street at the railroad) as the first station. The street-level crossings at Penn Avenue, South Avenue, Franklin Avenue, Wood Street, and Rebecca Avenue were very dangerous. In 1898, the *Pittsburgh Press* reported that a driver and four children were hurt when their cab was struck by a train and literally cut in two.

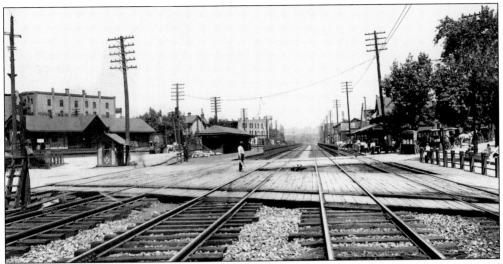

The growth of rail transportation led the Pennsylvania Railroad to lay four tracks along rail right-of-ways. The inside tracks were for express trains, the outside tracks for local service. Opposite the passenger station (right) was the freight station. A fifth, siding rail provided access for the freight cars. From 1852, when the railroad first came to Wilkinsburg, until 1916, all crossings were at street grade level.

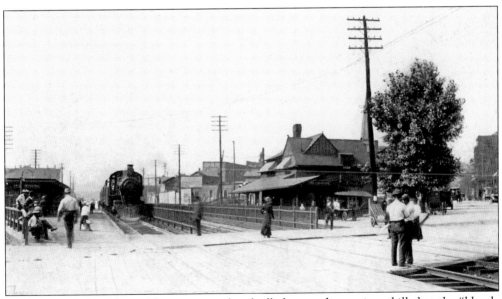

Children, older people, and horses were often badly hurt and sometimes killed at the "bloody crossings" by fast-moving trains. As seen in this photograph, safety railings were added outside the express train tracks in an effort to improve safety. A fatal accident in 1910 left only one child alive from a family of five. Within six years, the tracks had been raised and the streets lowered to provide safe crossings.

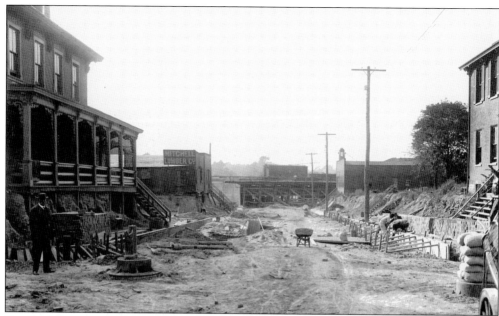

Finally, following a public uproar, work began in December 1912 to raise Wilkinsburg's two and a half miles of tracks and to lower the intersecting streets to eliminate the dangerous railroad crossings. The project took three and a half years. Penn Avenue was lowered as much as 10 feet approaching the raised tracks. The Seven Mile House is in the left foreground of this view of Penn Avenue looking west toward the overpass.

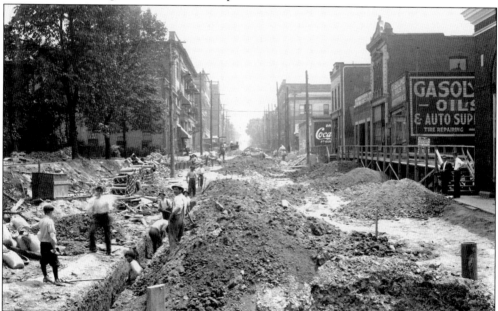

By 1914, Penn Avenue, Wood Street, South Avenue, Rebecca Avenue, and Franklin Avenue were closed and traffic restricted. Wooden sidewalks and crossovers were built. Some buildings were lowered; others were demolished. About 38,000 cubic yards of dirt were excavated in lowering the streets and 70,000 cubic yards for the entire project. Digging the trenches for utilities, as seen in this view of Penn Avenue looking east, cost the borough $105,000.

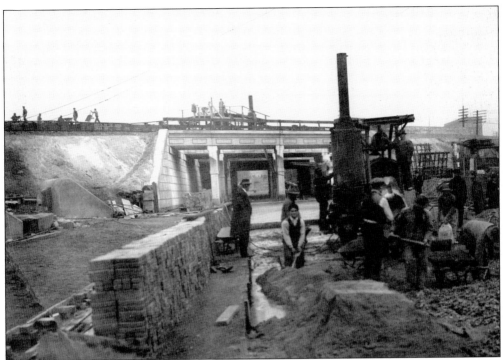

This 1915 photograph shows workmen placing ballast on the tracks above Penn Avenue. The concrete overpasses were completed first, and the sides of the raised track were constructed afterward. Steam-driven concrete mixers were used, pouring more than 51,000 cubic yards of concrete. Over 5.25 million pounds of structural steel were used. The stacked paving bricks were ready to be relaid as soon as the bed of the street was finished.

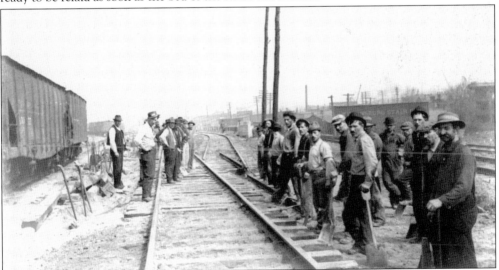

Replacing track, adding ballast, and lowering and rebuilding the streets required many workmen. Here railroad cars sit nearby loaded with a small part of the 750,000 cubic yards of the slag or crushed limestone that was required for the ballast. Many buildings along the track had to be razed or moved. In the background to the right is the Wilkinsburg Stair Company, founded about 1902 by Barnett, Young, and Kiser.

TRAINS BETWEEN STEWART, PITTSBURG, AND INTERMEDIATE STATIONS.

SCHEDULE IN EFFECT 2.00 A. M., NOVEMBER 27, 1904.

The time given on this table is Eastern Standard Time. The time between 12 o'clock, noon, and 12 o'clock, midnight, is indicated by heavy-faced type.

WESTWARD.—Week-days.

Miles.		1.5	2.9	4.2	4.8	6.1	6.8	7.3	8.0	8.9	9.6	10.2	11.3	12.5	13.3	13.8	15.7	16.0
	Leave Stewart	PITCAIRN.	Wilmerding.	Turtle Creek.	East Pittsburg.	Bessemer.	BRADDOCK.	Copeland.	Hawkins.	Swissvale.	Edgewood.	WILKINSBURG.	Homewood.	Fast Liberty.	Roup.	Shadyside.	...th Street	PITTSBURG
203	...	5.55	5.58	6.01	6.03	6.06	6.08	6.10	6.12	6.14	6.16	6.18	6.21	6.24	6.26	6.28	6.32	
203	6.30	6.15	6.18	6.21	6.23	6.26	6.28	6.30	6.32	6.34	6.36	6.38	6.41	6.44	6.46	6.48	6.52	6.55
			6.41	6.39	6.41		6.47					6.55		7.00				7.00
651		6.48	6.51	6.54	6.56	6.59	7.01	7.03	7.05	7.07	7.09	7.11	7.14	7.04	7.19	7.21		7.18
205	...	7.03	7.06	...	7.10		7.14		7.19	7.21	7.23	7.26	7.29	7.31	7.33	7.37		7.28
207		7.17	7.20		7.24		7.28	7.30	7.32	7.34	7.36	7.38	7.41	7.46	7.48	7.52		7.40
10		7.31	7.34				7.41							7.50				7.55
211		7.36	7.39	7.42	7.44		7.48	7.50	7.52	7.54	7.56	7.48	7.51	7.54	7.56	7.58	8.02	8.00
213		7.52	7.55		7.59		8.03					7.58	8.01	8.04	8.06	8.08	8.12	8.05
283	7.49											8.10	8.13	8.16	8.18	8.20		8.15
215		8.02	8.05		8.09		8.13	8.15	8.17	8.19	8.21	8.23	8.26	8.29	8.31	8.33	8.40	8.27
217		8.15	8.18	8.21	8.23	8.26	8.28	8.30	8.32	8.34	8.36	8.38	8.41	8.44	8.46	8.48	8.52	8.40
221		8.39	8.42	8.45	8.47		8.51		8.55	8.34	8.36							8.55
223		8.50	8.52	8.56					8.55	8.57	8.59	9.02	9.05	9.07	9.09		9.15	

By 1870, a total of 28 local trains between Stewart and the city of Pittsburg(h) ran through Wilkinsburg daily. This part of a water-stained train schedule, discovered between a pew and the wall during a renovation of St. Stephen's Episcopal Church in Wilkinsburg, shows how convenient travel by rail was in 1904. The round-trip fare from Wilkinsburg to Pittsburgh was 34¢. Railroad commuter service ended in June 1966.

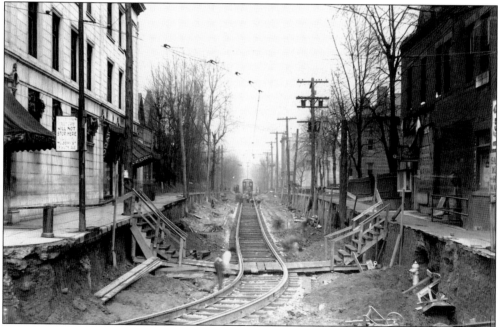

Signs were posted advising trolley riders that "Due to street construction, street cars will not stop here. Please go to Mulberry Street or South Avenue." On Franklin Avenue at Wood Street, the street and its trolley tracks were lowered more than eight feet. In the distance, workmen are laying tracks on temporary wooden ties. An additional lower floor was yet to be added to the Milligan Building on the left.

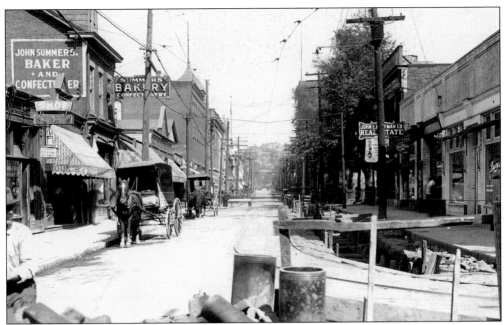

The lowering of Wood Street began in 1914 in the block between Franklin and Rebecca Avenues. Trenches like the one on the right were dug to accommodate utilities. Eventually buildings and sidewalks were lowered to match the new roadway. Until that work was completed, the entrances to some stores were left 5 to 10 feet above street level, and customers and proprietors had to climb ladders to enter the stores.

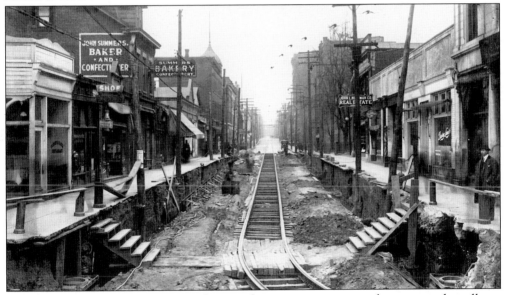

With Wood Street lowered five to six feet, reinforcements were required to prevent the collapse of existing sidewalks. Makeshift pedestrian walkways with wooden steps were constructed across the muddy, unfinished streets. Some buildings along Wood Street near the railroad were demolished; others were lowered to the new street level. Some buildings on Franklin Avenue remained as they were. For the more substantial buildings, a former basement became the new first floor.

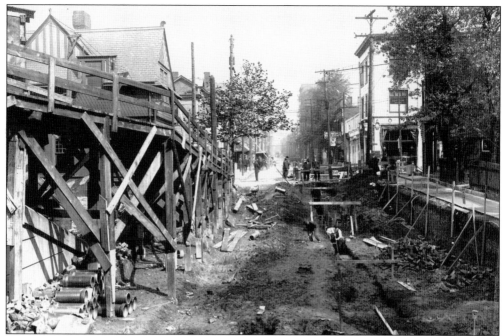

The lowering of Wood Street continued with construction of a wooden ramp giving rail passengers and workmen access to the new track level. Workmen dug trenches for utilities while sidewalk supervisors observed the process. The buildings on the right were lowered or removed. The lower floor of the Milligan Building (top right) had not been started nor alterations made to the buildings farther along the block.

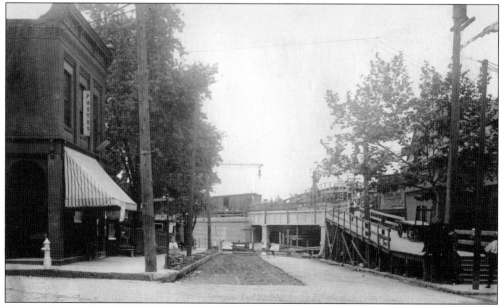

The newly completed Wood Street overpass is seen here, looking south on Wood from Franklin Avenue. The street bricks on the left side of Wood Street are still to be laid. The repaving of Franklin Avenue has been finished, and the trolley tracks are back in place. The wooden walkway leading up to the railroad station is still in place. This image was taken about 1915.

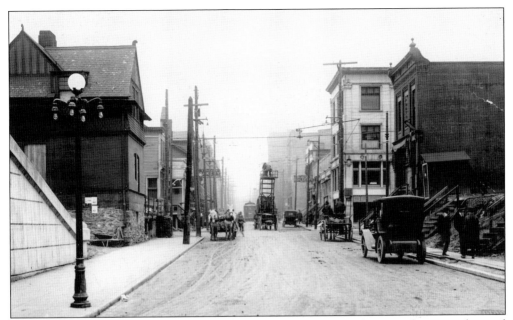

This 1916 view, looking north from Rebecca Avenue, shows Wood Street after it was lowered and repaved. The first building on the right is still at its original height, as is the old train station across the street. The second building on the right is the Milligan Building with its new first floor (formerly the basement) complete. Streetcar company workmen atop an elevated platform (center) are finishing the trolley cables.

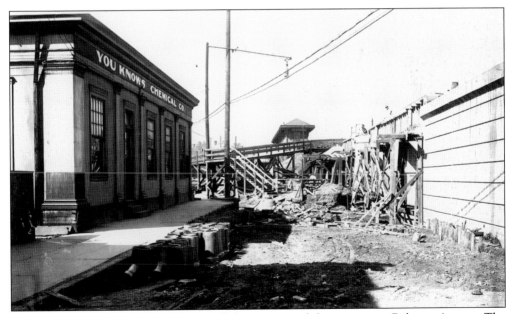

This 1915 view looks north on Pennwood Avenue toward the overpass at Rebecca Avenue. The overpass was still under construction, as indicated by the scaffolding. The wooden stairs lead up to the railroad platform. You Knows Chemical Company was still in business then. Sewer manholes project above the unfinished Pennwood Avenue.

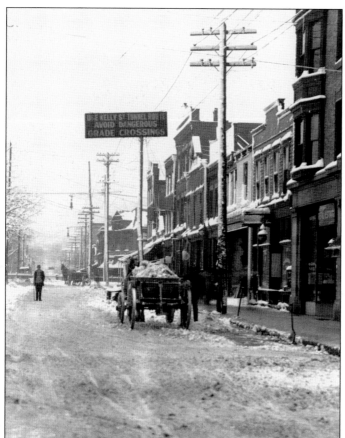

"Use Kelly St. Tunnel Route. Avoid Dangerous Grade Crossings," advises the overhead sign. In 1907, a mother wrote, "My son went to the library. . . . When he came home he had seen a boy crossing the railroad tracks. . . . An express train was coming. The train hit him and cut off his legs." This 1914 photograph also shows snow being removed on Rebecca Avenue and piled in a horse-drawn wagon.

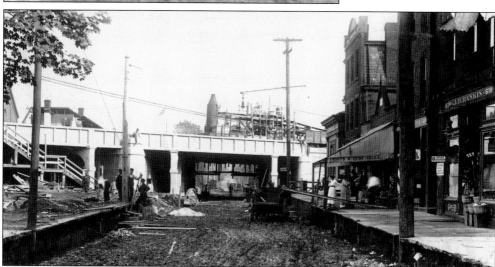

Rebecca Avenue, looking east, is being prepared for brick paving in 1916. On the right is a fruit and vegetable business. Many of the merchants on the west side of the railroad "wall" experienced a decline in business after the railroad was raised, as they were now cut off from the central part of the business district. The temporary wooden steps on the left lead to the old station area.

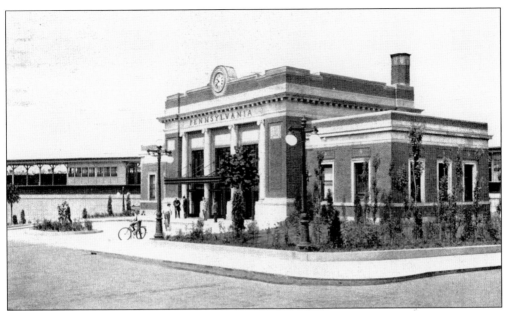

This stately Pennsylvania Railroad station opened in Wilkinsburg in April 1916. Called the most handsome passenger station in the entire Pennsylvania Railroad system, it was a model of classic architecture, constructed of granite and limestone. The interior was of vitrified Kittanning brick with marble trim and brass fittings. The station cost $350,000 and was beautifully landscaped. It had a semicircular drive and ornate lamp columns with decorative globes.

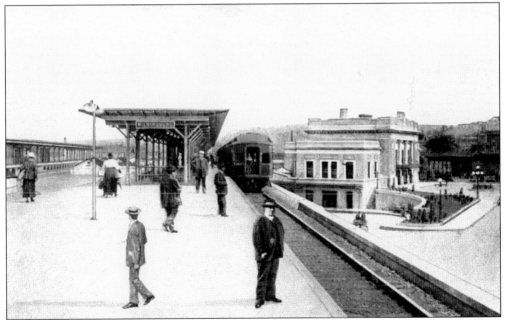

This was one of the first stations on the Pennsylvania Railroad to have elevated platforms level with the floors of the passenger coaches. These platforms were 1,000 feet long. At a cost of $3 million, the Pennsylvania Railroad successfully eliminated five grade crossings in Wilkinsburg. Elevating the four-track main line onto massive concrete structures took three and a half years of demolition and construction and was completed in April 1916.

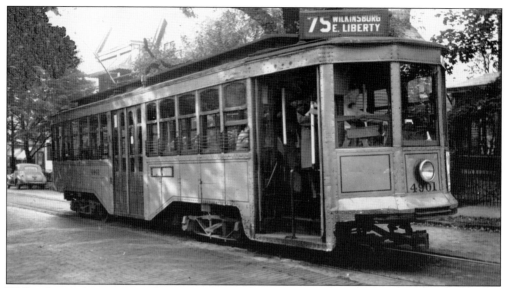

Wilkinsburg's first streetcar line was built by the Duquesne Traction Company in 1892. The town's railroad crossings became a concern because trolley tracks were not allowed to intersect railroads. The 75 Wilkinsburg–East Liberty, shown in this 1944 photograph, was one of the earliest trolley routes. It entered Wilkinsburg on Penn Avenue, continued to South Trenton Avenue, to Franklin Avenue, and ended at Hay Street, where a double track allowed a layover.

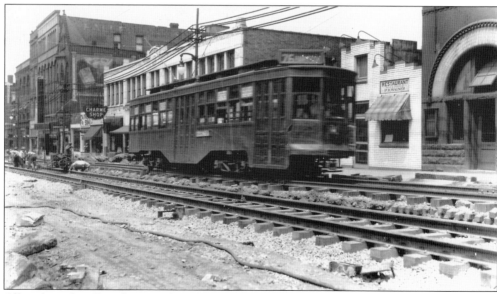

All outbound trolleys from Pittsburgh used a single center track on Penn Avenue. During the summer of 1936, Wilkinsburg was repaving borough streets. Pittsburgh Railways had to lay new trolley tracks, so a bypass track was used. The businesses seen here on the north side of Penn Avenue are (from left to right) the Penn Building, Paul R. Wagner's Restaurant, and the Belmar Moving and Storage Company.

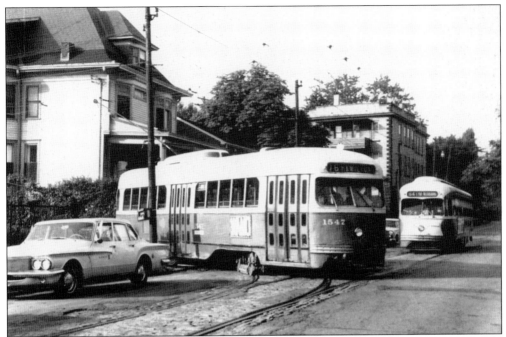

For over 50 years, trolleys were the main transportation for Wilkinsburg residents. This 76 Hamilton trolley is turning off at the end-of-the-line Jane Street turnaround. Since the late 1890s, signs in Wilkinsburg had advertised, "Take Yellow Car Line to Kennywood." From the early 1900s, that line carried enthusiastic children to their annual school picnic at Kennywood Amusement Park.

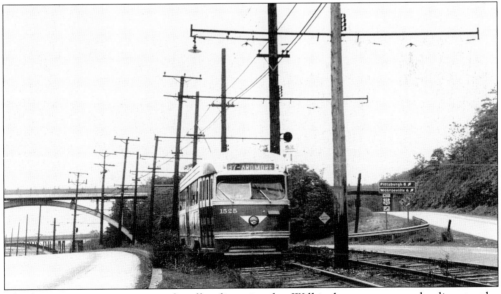

The last major construction of trolley lines in the Wilkinsburg area was the line to the Westinghouse Electric Company in East Pittsburgh in 1910. The streetcar known as 87 Ardmore entered Wilkinsburg from Pittsburgh at Tioga Street and then ran to Wood Street, to Penn Avenue, to Swissvale Avenue, to Franklin Avenue, to Ardmore Boulevard, and then into Forest Hills. All trolley service in Wilkinsburg ended in January 1967.

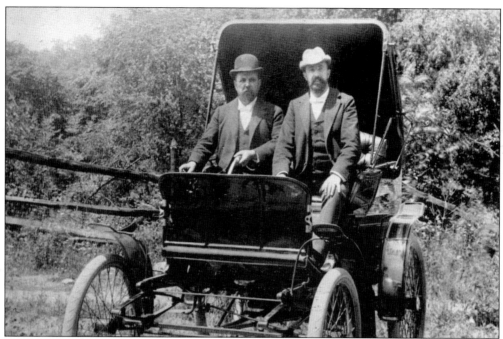

Wilkinsburg physicians William and Thomas Stephens purchased this one-cylinder Winton in Cleveland in 1898 at a cost of $1,000. This automobile was the second ever owned in Pennsylvania. It was shipped by rail to the Pennsylvania Railroad station at Eleventh Street in Pittsburgh and then driven to Wilkinsburg. The vehicle weighed 1,600 pounds and rode on Dunlop tires. Steered by a tiller drive, it had two forward speeds and one reverse.

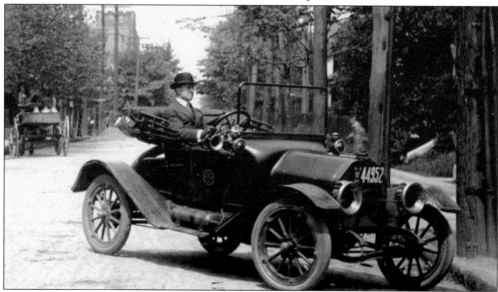

Two of the most significant influences in the development of Wilkinsburg were the railroad and the automobile. The Wilkinsburg Automobile Club was organized in October 1906 with 22 men, each the proud owner of a "horseless carriage." The membership fee was $1, and benefits included road repairs and the use of Pennsylvania and Ohio maps hung on the walls of the clubroom. The speed limit was 15 miles per hour.

Seven

COMMUNITY LIFE

In January 1814, the Beulah Presbyterian Church congregation organized a church library, said to be the first subscription library west of the Allegheny Mountains. Residents of the village of Wilkinsburg known to have shares in the library included Col. Dunning McNair, David Little, James Horner, William Park, and Lewis Satterfield. A share was worth $2.50. The shareholders adopted rules and purchased over 35 books, including *The American Revolution* and *Newton's Works*. By 1898, the Wilkinsburg Public Library had opened in a McNair School classroom with 2,500 volumes.

Letter writing was an important form of communication in the 19th century. The first post office in the village was established on May 20, 1840, under the name Wilkinsburgh. The postage rate was based on the number of sheets and the distance of travel. In 1843, the rate for a single sheet traveling less than 30 miles was 6¢. By 1883, the letter rate had been reduced to 2¢.

Elizabeth Pratt, in the 1937 50th anniversary *Nugget* wrote,

The famous quip "that when two Englishmen meet, they organize" is applicable to Wilkinsburg. Wilkinsburg has scores of human organizations containing the associated old and young, male and female—embracing practically every activity of human thought. Hundreds of the citizens of this community have formed groups for purposes fraternal, civic, religious, political, charitable, social and educational and the good wrought the Borough by these countless organizations is incalculable.

In times of distress or disaster the noble folk of Wilkinsburg have never hesitated to immediately take up their duties to those who need friendly hands and warmth and shelter and aid. Theirs is a long, golden record of achievement, the count of which is known only to God.

In times of celebration or the need of progress, our men and women respond with the same eagerness to contribute their weighty might toward the advancement of the pleasures and happiness of Wilkinsburg.

Wilkinsburg is proud of its organizations—they are as necessary to the welfare of the community as the sunshine is to our trees.

During World War I, the American Red Cross organized women into community auxiliaries. The women, usually in church-based groups, collected garments, knitted articles, assembled front-line packets, and made surgical dressings to be sent to Belgium and France. Junior auxiliaries were organized in the public schools. The executive committee of Wilkinsburg's Red Cross Auxiliary, organized in March 1917, is pictured here in the fashions of the day.

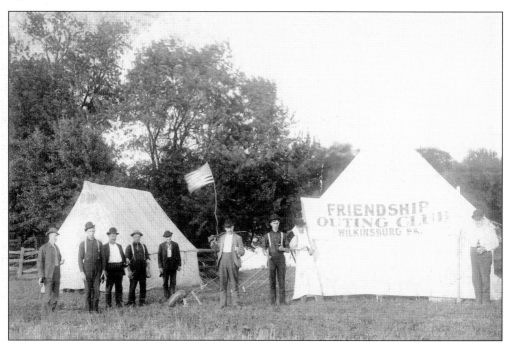

People gather together for any number of reasons. The patriotic gentlemen at this 1905 gathering at Cambridge Springs announce their purpose as friendship. The club's bylaws may have required members to wear hats and be able to handle a bottle, most often with a liquid content.

The Wilkinsburg Historical Society has its roots in this assembly of citizens who were so interested in the borough's past that they organized the Group for Historical Research on Wilkinsburg Village and Environs 1788–1888 on June 11, 1934. At this initial meeting, it was agreed that events in the early years of the village were too important to be lost. In 1940, they published the 550-page *Annals of Old Wilkinsburg and Vicinity*.

The Sheridan Sabres assembled in 1939 to celebrate their 50th year as a semimilitary organization. The group formed in 1889 as a well-drilled company of men with a full 36-piece military band. At their peak, they had a membership of 160. They performed in Pittsburgh and other western Pennsylvania communities. To raise funds, they conducted an annual circus, for which they borrowed an elephant from the Highland Park Zoo.

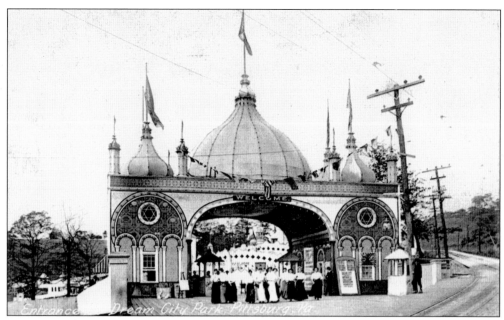

Owner and designer W. F. Hamilton opened Dream City amusement park in May 1906. This entrance, at the intersection of Laketon Road, Montier Street, and Verona Road (now Robinson Boulevard), led to a 20-acre park with an artificial lake at the center. The park offered five acres of picnic grounds and a great variety of rides and shows. Among the park's features were evening fireworks and 150,000 electrical lights.

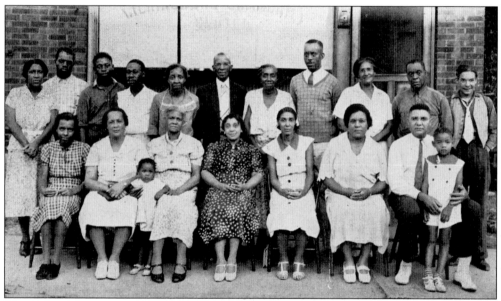

The Colored Community Club of Wilkinsburg was organized in 1931 at the St. Mark African Methodist Episcopal Church. Its purpose was to help needy people. Participation grew, so the club moved to a larger meeting place at 1404 Montier Street. Members assisted the Red Cross, took classes in cooking, and learned advanced first aid. The club also sponsored a Girl Scout troop, a sewing group, and an industrial club.

Yes, Wilkinsburg had an airport, but for less than a decade in the 1930s. It was located in Blackridge and had a flight area bounded by Graham Boulevard on the west, Orlando Drive on the north, Hollywood Drive on the south, and the area beyond Yorktown Place on the east. Air shows were very popular at the time. The one advertised here featured local "girl stunt pilot," Theresa James.

On September 10, 1899, the Wilkinsburg Branch of the Carnegie Free Library of Braddock opened in the McNair School with 1,500 books. It was the first Carnegie branch. Frederic S. Evans was head librarian; his assistant was Mabel Egbert. The library's hours were 10:00 a.m. to 9:00 p.m. In 1940, the library relocated to the municipal building. In this September 1959 photograph, patrons and librarians celebrate the library's 60th anniversary.

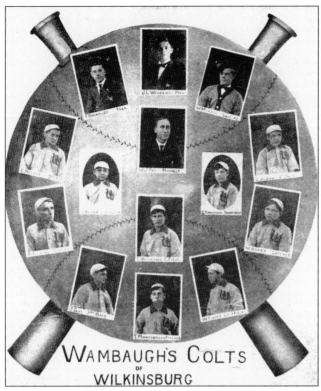

WAMBAUGH'S COLTS
OF
WILKINSBURG

In the early 1900s, baseball was the most popular sport in America. One of Wilkinsburg's teams was Wambaugh's Colts, sponsored by Wambaugh's Drug Store on Glenn Street and Swissvale Avenue. The team had 10 players (including two pitchers), a manager, and its own umpire. Admission to its games was free, but during the seventh-inning stretch, the team took up a collection by passing a hat among the fans.

In the early days of the 20th century, most churches in the area had a youth baseball team. These young men from the First United Presbyterian Church played in a church league. The league's games were held at the Duquesne Country and Athletic Club Park, known as the DC and AC Park. The park was bounded by Hill Avenue, Wood Street, North Avenue, and Hay Street.

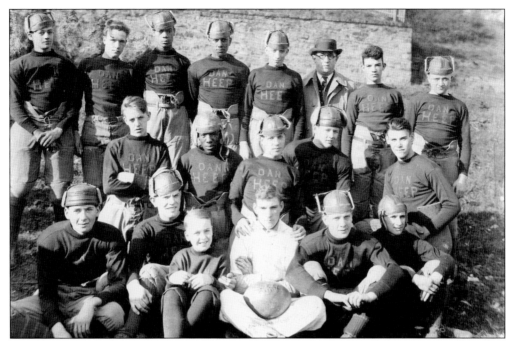

Sheridan P. Heep, better known as Dan Heep, was a meat dealer, an honest and soft-spoken man. He served on Wilkinsburg Borough Council from 1932 to 1940. He loved football and sponsored this sandlot team in 1921. Heep is in the back row, wearing a felt hat. There were a number of semiprofessional football teams in Wilkinsburg over the years, including the Prescott Indians in the early 1950s.

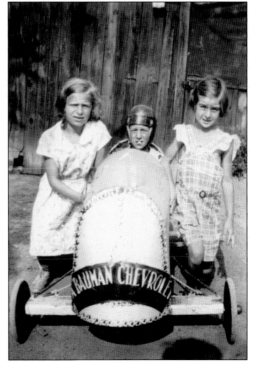

Bauman Chevrolet celebrated 50 years as a dealership in 1970. The Bauman brothers opened their business at South Avenue and Hay Street before moving to the site of the present municipal building. They moved then to Braddock and finally back to Wilkinsburg to the site where McDonald's stands today. In the 1930s, they sponsored the local soapbox derby. The races were held on Laketon Road near Turner School.

The Wilkinsburg Woman's Club was organized in November 1898. This photograph of the club's 1937–1938 officers and others represents women who did philanthropic work within the Wilkinsburg community. Over the years, they have furthered reform and improvements and provided scholarships to high school students. The club became so large at one point that a junior group and an evening group were organized.

Wilkinsburg Lodge No. 577 of the Benevolent and Protective Order of Elks was founded on May 31, 1900, with 29 members present. By 1916, the Elks had moved to the former Pennwood Club on Ross Avenue. Then in July 1944, they moved to this property at the corner of Penn Avenue and Peebles Street. The house is the former residence of Frank Conrad and the birthplace of radio station KDKA.

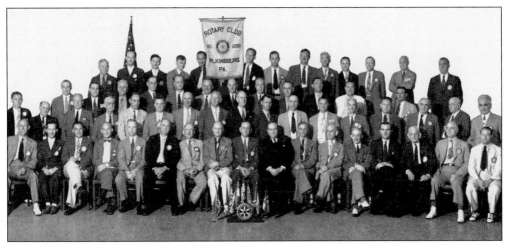

The Wilkinsburg Rotary Club was organized by local businessmen in 1922. The club's mission is service to children. In 1935, local Rotarians were leaders in promoting the Wilkinsburg Boys Club. They built a cabin for the Boy Scouts at Camp Twin Echo. They also participated in the Rotary International's student exchange program. For many years, their Tuesday luncheon meetings were held at the Penn Lincoln Hotel.

The Kiwanis Club of Wilkinsburg was formed in October 1927 to serve the community's children. The club meets weekly for a lunch program that includes a speaker. Initially an organization of businessmen, the club began to include women in 1987. In 1938, the Kiwanians in this photograph presented an all-male show called "The Womanless Wedding" in the high school auditorium. The club holds an annual Christmas party for needy children.

The Westinghouse Club was a recreation center for Westinghouse Electric Company employees. It opened in 1902 at 501 Pennwood Avenue, northwest of the Kelly Avenue underpass. In 1941, the club members started an orchestra that performed for the next six years. The Wilkinsburg Chamber of Commerce took over sponsorship of the orchestra in the fall of 1947. Eugene Reichenfeld, the conductor, is in the center holding the baton.

Boy Scouts have been part of Wilkinsburg since the organization was founded in America on February 8, 1910. Almost every church sponsored a troop. The East Boroughs Boy Scout Council included many eastern Allegheny County communities. The Scouts' summer camp was Camp Twin Echo near Ligonier. Here are the members and leaders of Troop 22, sponsored by South Avenue United Methodist Church, attending a district court of honor in March 1932.

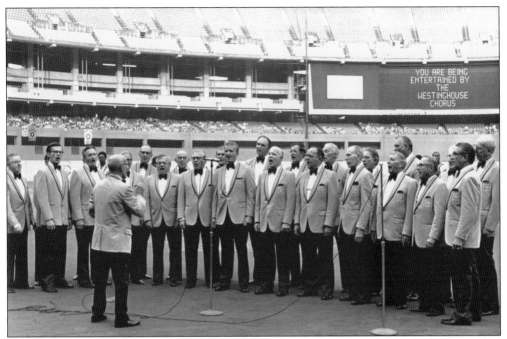

The Westinghouse Male Chorus, formed in 1928, had its roots in the Westinghouse Club, which was founded in 1902. The first director was O. W. Grosskopf. Robert O. Barkley, the Wilkinsburg School District's supervisor of music, became the director in 1943. In 1956, the Christian Church of Wilkinsburg choir director, Theodore (Ted) Yearsley, took over the 25-member chorus. The chorus sang at many local events as representatives of the Westinghouse "Circle W" firm.

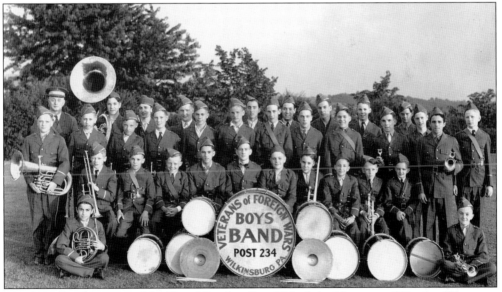

The Boys Band, sponsored by David Rankin Post 234 of the Veterans of Foreign Wars, was organized in 1928 with 30 members. John Bennett (back row, far left) was the musical director. Its first outdoor performance was on Memorial Day 1929 at Woodlawn Cemetery. The 1937 band, shown here, won first prize for junior bands at the Pennsylvania State Convention of Veterans of Foreign Wars in Reading.

In 1907, Orient Lodge No. 590, Beta Lodge No. 647, and the Wilkinsburg Royal Arch chapter formed an association. They purchased property at 747 South Avenue to build this temple for the Masons of Wilkinsburg. The cornerstone was laid on July 22, 1916. This temple was also home for the Lincoln Commandery No. 91 of the Grand Commandery Knights Templar, Wilkinsburg Lodge No. 683, and Samuel Hamilton Lodge No. 746.

The Pennwood Club, a prominent social organization, was organized in November 1904. Its name came from a combination of the names of two principal Wilkinsburg streets, Penn Avenue and Wood Street. The club completed this building at 742 Ross Avenue in 1906. The Benevolent and Protective Order of Elks took over the building in 1916. The Young Women's Christian Association has been located here since 1946.

Eight

CELEBRATIONS AND REMEMBRANCES

Wilkinsburg loves parades, especially to commemorate important events and to celebrate great occasions—and even for ordinary occasions. For many years, the Wilkinsburg High School marching band assembled at noon on home-game Saturdays. The band marched from the high school to Graham Field for the football game and back to the high school again when the game was over.

The community has had many celebrations, most of them including parades. In 1898, Wilkinsburg had the Old Settler's Association gala. Every 25 years (1912, 1937, 1962, 1987), the community has celebrated the 1887 incorporation of the borough. For years, the veterans and others marched from the business district up Penn Avenue hill to Woodlawn Cemetery for a special remembrance on Memorial Day. There were also special recognitions and festivities when celebrities such as Adm. Richard E. Byrd and Amelia Earhart came to town.

Some say the greatest Wilkinsburg parade ever was on June 10, 1916, part of the three-day celebration of the elimination of the railroad grade crossings. This parade was four miles long and had 75,000 spectators. On the day before, the children of Wilkinsburg presented the life-size copper statue of Abraham Lincoln that stands today in Point Park on Penn Avenue at Ardmore Boulevard.

Two very special celebrations were held in Wilkinsburg as they were in communities all across America—those marking the ends of the world wars in 1918 and 1945. As soon as the news came, people poured into the streets, shouting, crying, laughing, and embracing one another. Horns honked, church bells rang, and whistles from the mills and locomotives blew. And soon thereafter, of course, came the parades.

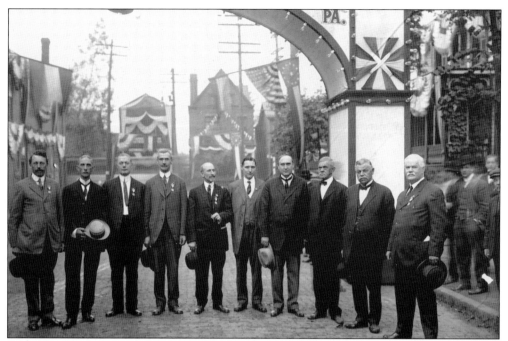

Borough officials are standing under a lit arch on Ross Avenue during the borough's 1912 25th anniversary celebration. Frank B. Tomb, burgess, is on the far right; next to Tomb is Jacob Weinman Sr., borough council chairman. Second from the left is William G. Ewing, street commissioner. Ewing saved the Seven Mile Stone and led the effort to include schoolchildren in financing the Abraham Lincoln statue in 1916.

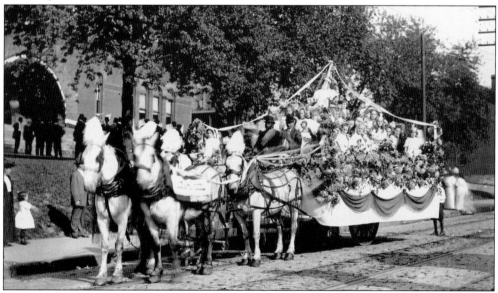

It was a grand parade! On Saturday, October 5, 1912, the Borough of Wilkinsburg was 25 years old. Each school had a decorated float. Here is Horner School's float in front of the school on Wallace Avenue. The 2:00 p.m. parade started at Biddle and Trenton Avenues, traveled down 17 different streets, and then proceeded to the ball fields at Montier Street. A dinnertime barbecue and a band concert followed.

In 1881, Thomas D. Turner Sr. opened an undertaking and livery business at 720 Penn Avenue. The undertaker provided an embalming service, a casket, and a horse-drawn hearse. Funerals were conducted in the grieving family's home. The livery had a boarding stable and rented carriages and horses. Here Turner's establishment is decorated for the borough's 1912 25th anniversary celebration. Later Turner moved to a newer building on Penn Avenue.

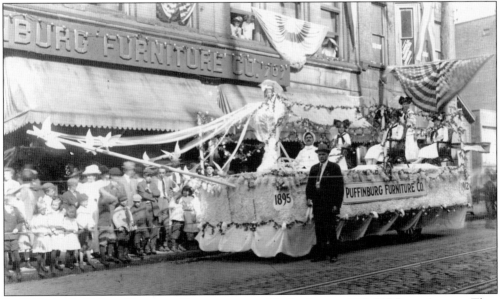

In 1895, the Puffinburg Furniture Company opened for business at 705–707 Penn Avenue. They offered home furnishings, made-to-order carpets, upholstering, shades, awnings, and mattresses. The store was "Open Saturday evenings til 10." Many local businesses created floats for the borough's 25th anniversary parade in 1912. A. J. Puffinburg is seen here in front of his store with his lavish entry. In 1924, the business was sold to Faller's Better Furniture.

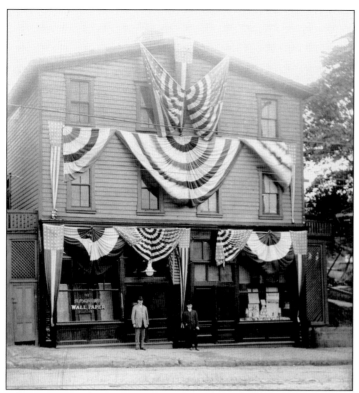

Wilkinsburg marked its 25th year as a borough in 1912. On October 3–5, many of the town's buildings were gaily decorated. Games, races, concerts, parades, and speeches entertained the entire community. This photograph shows the Curry Wallpaper and Paint store at 913 Penn Avenue with its banners and bunting in place.

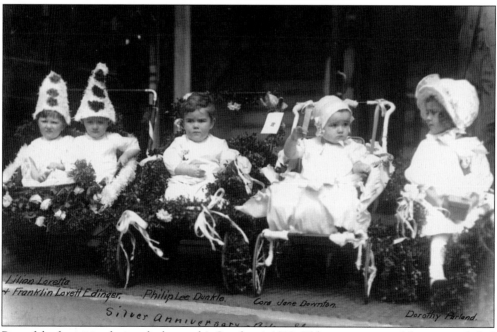

Part of the festivities during the borough's October 4, 1912, 25th anniversary celebration included a baby parade on Wallace Avenue from Wood Street to Center Street. Mothers walked their decorated baby carriages past a panel of judges who awarded prizes for best-decorated carriage, fattest baby, best-natured baby, and best-looking baby. The happy winners are pictured here.

The railroad tracks were raised, the streets were lowered, and the grade crossings were eliminated. The work started in December 1912 and ended three and a half years later in April 1916. On June 10, 1916, the community celebrated the improvements with a grand parade. Some 75,000 people gathered for the festivities. Among the decorations was this commemorative pennant.

Children with tuberculosis were usually quarantined in a sanitarium. Some were allowed to go home to sleep in shacks like this one. Wilkinsburg carpenters built a shack for each child and set it up in the family's yard. The Wilkinsburg Anti-Tuberculosis League used this shack as a float in the June 1916 parade that was part of the Grade-Crossing Elimination Celebration.

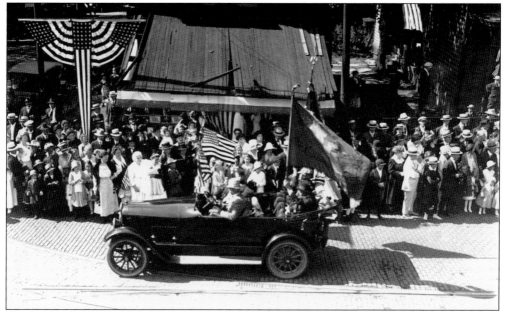

Over 1,180 uniformed men and women, bands, dignitaries, and civic groups marched in the September 1919 parade. Injured veterans and veterans of the Grand Army of the Republic rode in cars like this one. The parade route ran along Penn Avenue from Wood Street to Swissvale Avenue, back down Penn Avenue, then up Wood Street to DC and AC Park. Speeches honoring the veterans were given at the park.

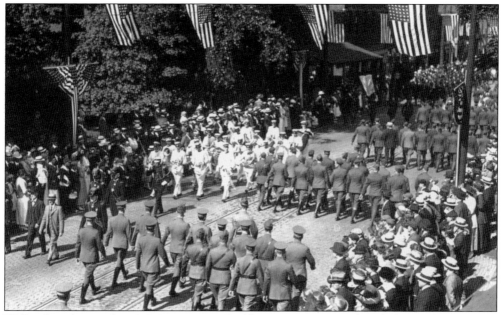

Wilkinsburg honored its 2,043 returning World War I veterans with a daylong celebration on Labor Day 1919. A veterans' parade and an open-air dinner for the hometown heroes replaced the usual Labor Day events. There were street bands, dancing, 21-gun salutes, and, of course, speeches. There was also a moment of silence for the 45 soldiers who did not return. The entire town was decorated in red, white, and blue.

The Mothers for Democracy provided an open-air dinner for the returning heroes in September 1919. It occupied two blocks of South Avenue from Wood Street to Center Street. Church kitchens provided the food and the young women of Wilkinsburg served it to the 1,180 veterans. A large memorial to the 45 who gave their lives in the fight for democracy stood in the center of this outdoor dining room.

Wilkinsburg erected this octagonal honor roll pagoda in a small park on Wood Street at Franklin Avenue. The eight panels listed 2,088 men and women from Wilkinsburg who served in World War I. The pagoda was dedicated on November 23, 1918, following a great street parade. The $3,500 for the memorial was paid for by public subscription. The Pennsylvania Railroad donated the land for the park.

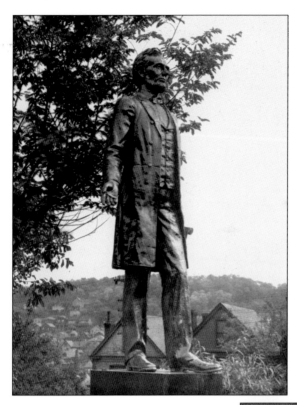

On June 9, 1916, a statue of Abraham Lincoln was placed by Wilkinsburg schoolchildren at Point Park on Penn Avenue at Ardmore Boulevard. Over the last 90 years, the statue has fallen or been taken off its stone pedestal several times. Once it was removed by vandals. The statue was eventually reset every time. The latest restoration and rededication was on April 30, 2001, by the Wilkinsburg Historical Society.

In 1926, Wilkinsburg schoolteacher Alice Johnston and her students sponsored this doll, one of nearly 15,000 sent in friendship to the children of Japan. During World War II, the Japanese government declared the dolls enemies of the state, and most were destroyed. "Alice," one of about 400 that survived, was found, saved, honored, and loved by the children of the Jinryo Elementary School in Kamiyama, Japan, where she lives today.

"In Flanders Fields the poppies blow / Between the crosses, row on row." These opening lines from John McCrae's World War I poem made the red poppy a symbol of war's ultimate price. Here the members and friends of Wilkinsburg's Ladies Auxiliary to the Veterans of Foreign Wars gather to begin the 1929 sale of their "Buddy Poppies." Proceeds funded services to veterans in need.

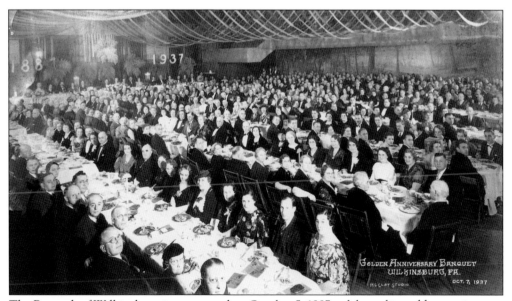

The Borough of Wilkinsburg, incorporated on October 5, 1887, celebrated its golden anniversary in 1937. Jubilee events were scheduled from spring through fall. The highlights included a dramatization of Wilkinsburg's history called "Our Yesteryears," a Boy Scout camporee, a baby parade, Fourth of July fireworks, an outing at Kennywood Amusement Park, a ball, a gala parade, and this grand banquet in the high school gymnasium.

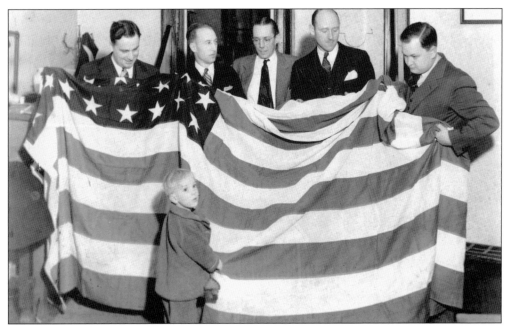

On January 1, 1940, the Wilkinsburg Elks Lodge No. 577 gave the borough a flagpole and the flag shown here. The flagpole, which still stands at the corner of Ross Avenue and Hay Street, was dedicated as part of the huge celebration marking the opening of the new municipal building. The granite memorial later placed at the base of the flagpole honors Wilkinsburg veterans of the Korean and Vietnam conflicts.

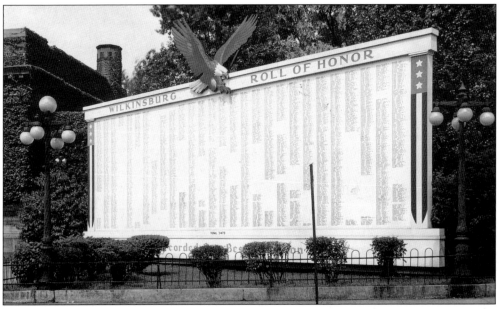

After World War I, Gen. John Pershing honored Wilkinsburg for contributing more men to the armed forces in proportion to its population than any other community in America. During World War II, the community honored military men and women with this huge recognition board next to the railroad station. There were 3,479 names on the board. By the end of the war, there were over 4,000.

One of the first official celebrations of the Wilkinsburg Fire Department was this 51st anniversary banquet held on February 18, 1954. Organized by Chief William "Bucky" Thomson, the dinner was held in the fire station garage. Among the 150 guests were borough council members, police officers, retired firefighters, the county sheriff, Pittsburgh's fire chief, a few judges, and even a representative from American LaFrance, the fire truck manufacturer.

This horse-drawn surrey participating in Wilkinsburg's diamond jubilee was owned and driven by Dr. James Ballantyne. He was an orthopedic surgeon who maintained an office on Trenton Avenue and operated at nearby Columbia Hospital. An avid collector of old horse-drawn carriages, Ballantyne often participated in parades and other civic events. In this 1962 parade on Pennwood Avenue, he carries the Wilkinsburg Historical Society banner on the rear of his carriage.

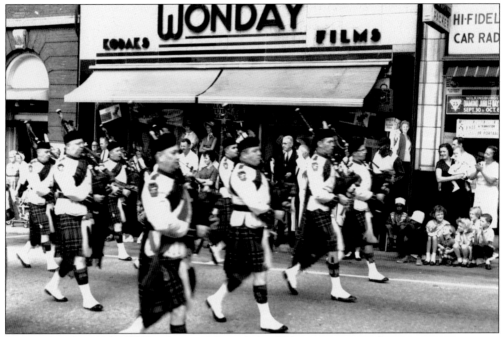

During October 1962, Wilkinsburg celebrated the 75th anniversary of its incorporation as a borough. The grand parade included a large number of units from the Syria Shrine, including the Highlanders Pipes and Drums seen here on South Avenue. Wonday, the film-processing company seen in the background, remains at that same location today.

The 100-member Wilkinsburg High School band marches along Wood Street near South Avenue in the borough's 1962 diamond jubilee parade. Richard L. Camp directed the band from 1950 to 1970. The Tiger Band was begun in 1926 when Richard Matson was employed to teach boys to play musical instruments. Other directors were Paul Slater in 1928 and Elwood N. Scott in 1931. Until 1950, only boys played in the band.

Nine

WILKINSBURG'S LEGACY

For over two centuries, Wilkinsburg has been the home of heroes, leaders, pioneers, artists, and inventors—men and women who have made their marks on the community, the nation, and the world.

Col. Dunning McNair purchased the land on which he founded the village. He laid out the street plan that still forms the center of Wilkinsburg. James Kelly influenced the future of the village: he donated the land for schools and churches, fought the annexation of the village by Pittsburgh, and led the campaign to outlaw the sale of alcohol.

Jane Grey Cannon Swisshelm was an educator, a journalist, and a lecturer. She campaigned for women's rights and the abolition of slavery. Teresa James flew in the Women's Auxiliary Ferrying Squadron during World War II.

Oliver Livingstone Johnson, a World War I veteran, became Allegheny County's first African American district attorney. The first director of fine arts at the Carnegie Museum was John Wesley Beatty. He established the now-famous Carnegie International exhibitions.

Frank Conrad's pioneering work in radio led to the establishment of KDKA, the first commercial broadcast radio station. Inventor Louis W. Yagle gave the world a set of apothecary weights that greatly improved the precision in measuring medications.

The first Carnegie Hero Medal went to Louis A. Baumann Jr., who risked his own life to save a friend from drowning. Thousands of Wilkinsburg's sons and daughters—unsung heroes—have served on the battlefield, from the Revolutionary War to Iraq.

Many others have left legacies of their own, and in doing so, they have shaped the character of Wilkinsburg.

Commercial radio broadcasting began in Frank Conrad's garage on Penn Avenue at Peebles Street. Conrad began working at Westinghouse Electric and Manufacturing Company in 1890. An amateur radio enthusiast, he began broadcasting recorded music in 1919. In 1920, his pioneer work in radio led to the establishment of KDKA, the world's first broadcasting station to offer continuous programming. Frank Conrad (1874–1941) was inducted into the Radio Hall of Fame in 1953.

In 1919, listening to radio was more like a science experiment than entertainment. There were no commercial radio stations, and most radio receivers were homemade crystal sets. Usually listeners heard amateur radio operators signal to each other in Morse code, but not when Frank Conrad was on the air. He began broadcasting from this garage next to his home on Penn Avenue in Wilkinsburg.

Maurice Richard Robinson (1895–1982) graduated from Wilkinsburg High School in 1915. He was class president and editor in chief of the high school's *Review*. He graduated from Dartmouth in 1920 and returned home to 715 Wallace Avenue. In October 1920, he began publishing a four-page weekly paper called the *Western Pennsylvania Scholastic*. In September 1922, it became *The Scholastic*, a magazine for high school students.

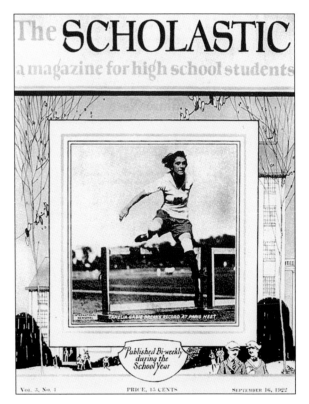

The Scholastic was first published in Wilkinsburg. Established in 1920 by Maurice Richard Robinson, it was a four-page biweekly distributed in 50 high schools. Today Scholastic Inc., located in New York, is the world's largest publisher and distributor of children's books. Scholastic's annual revenue is $2.1 billion, and it has over 10,000 employees. The *Scholastic* pictured here is the September 16, 1922, issue.

On Sunday, July 17, 1904, 17-year-old Louis A. Baumann Jr. (1887–1925) and Charles Stevick went swimming with friends in a pond on a Wilkinsburg farm. Stevick began to drown in the 10-foot-deep water. Baumann dove in three times before successfully rescuing Stevick. For this valiant act, he was awarded the first Carnegie Hero Medal, an award established by Andrew Carnegie to recognize those who risked their lives for others.

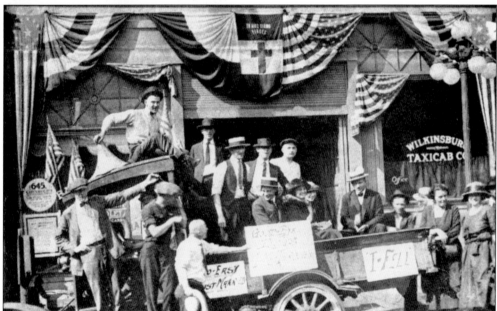

Louis Baumann, the first Carnegie Hero, started the Wilkinsburg Taxicab Company while two of his brothers were serving in World War I. Baumann's family and friends are seen here in front of the company office, celebrating his marriage in 1921. When his brothers returned from the war, the Baumanns acquired a Chevrolet franchise. The company was known as Bauman Brothers, with the spelling changed to omit the second n.

A Wilkinsburg High School baseball star, William Boyd McKechnie (1886–1965) began his professional career in 1907 with the Pittsburgh Pirates. He became the Pirates' manager in 1922. Under his management, they won the 1925 World Series. The St. Louis Cardinals won the National League pennant under his management in 1928. McKechnie also managed the Cincinnati Reds, winning the National League pennant in 1939 and the World Series in 1940.

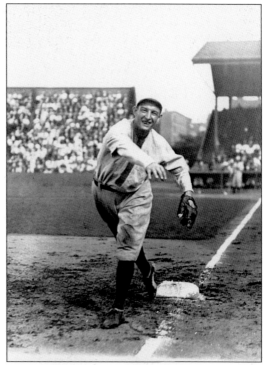

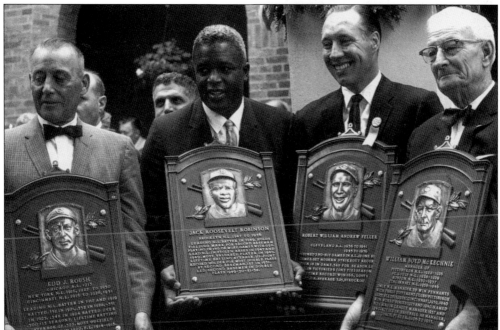

William Boyd McKechnie (far right) was elected to the National Baseball Hall of Fame in 1962. Also inducted that year were (from left to right) Edd J. Roush, a Cincinnati Reds center fielder; Jack Roosevelt "Jackie" Robinson, a Brooklyn Dodgers second baseman; and Robert William Andrew Feller, a Cleveland Indians pitcher. McKechnie sang in his church choir for years. Being both a churchgoer and a family man earned him the nickname "Deacon."

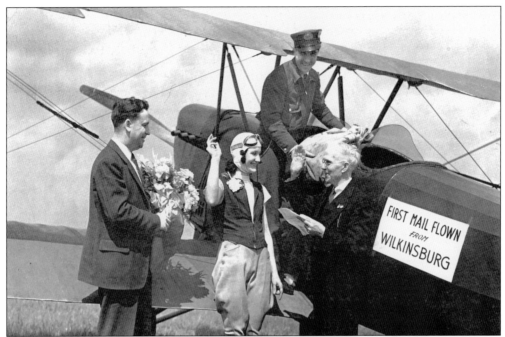

The Wilkinsburg Airport opened in 1930. It was bounded by Orlando Drive, Hollywood Drive, Graham Boulevard, and Yorktown Place in Blackridge. Teresa D. James, seen here, was chosen by postmaster James A. Farley to fly the only airmail delivery ever to originate from the Wilkinsburg Airport. She flew the mail to Bettis Field (Old County Airport). The last flight from the Wilkinsburg Airport was during National Mail Week in May 1938.

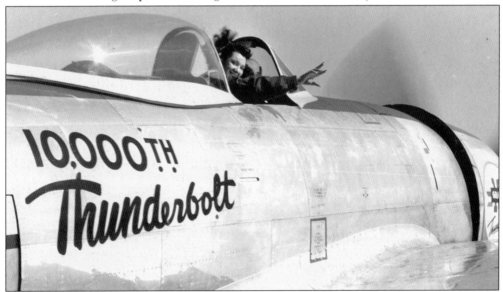

Teresa D. James (1911–) took her first solo flight in a biplane in September 1933, after only four hours of instruction. She was soon performing stunts at air shows at the Wilkinsburg Airport. The money she earned bought her more flying time so that she could qualify for a federal license. Flying in the Women's Auxiliary Ferrying Squadron during World War II, she rose to the rank of major.

Louis W. Yagle (1904–1997) was a 1925 graduate of the University of Pittsburgh School of Pharmacy. He opened the Yagle Pharmacy at 1525 Wood Street in 1926 and was there for 43 years. Yagle became a professor of pharmacy at Duquesne University, and he invented tools for pharmacists. He was an avid collector of United States Revenue stamps and a member of the Wilkinsburg Stamp Club.

One of Yagle's inventions was this set of apothecary weights, used to make more accurate measurements of medication dosages. These measurements are done electronically today, but at the time, these weights represented a considerable technological advancement. He also invented a prescription-pricing slide rule. His pharmaceutical tools, which were nationally known, have been on the market since 1946.

John Wesley Beatty (1851–1924) left Wilkinsburg in 1876 to study at the Academy of Fine Arts in Munich, Bavaria. On returning, he opened a studio in Pittsburgh and continued his study of art. He became the first director of fine arts at the Carnegie Museum of Art in 1896 and retired in 1922. In 1896, he brought an exhibition of paintings to Pittsburgh. The exhibition became the first Carnegie International.

Jane Grey Cannon Swisshelm (1815–1884) was a journalist, a lecturer, and a campaigner for women's rights and abolition. At the age of 15, she opened a village school in Wilkinsburg. She married in 1836 and divorced in 1857. She volunteered as a nurse during the Civil War. Swisshelm founded a newspaper, the *Saturday Visitor*, which reached a national circulation of 6,000. Her 1880 autobiography is titled *Half a Century*.

Oliver Livingstone Johnson (1889–1971) served in World War I. He attended Howard University and the University of Pittsburgh School of Law. Johnson became the first African American district attorney in Allegheny County. Johnson's oldest son was killed in World War II. Another son, Livingstone M. Johnson, is an Allegheny County Common Pleas Court senior judge and a third son, Justin M. Johnson, is a Pennsylvania Superior Court judge.

John Ralph McDowell (1902–1957) began editing the weekly *Wilkinsburg Gazette* in 1929. He became president of the Wilkinsburg Gazette Publishing Company in 1933. For 28 years, he wrote a weekly editorial called "The Country Editor." A Republican, he served two terms in Congress, 1939–1941 and 1947–1949. McDowell was a leading member of the House Un-American Activities Committee and was known nationally for his opposition to Communism.

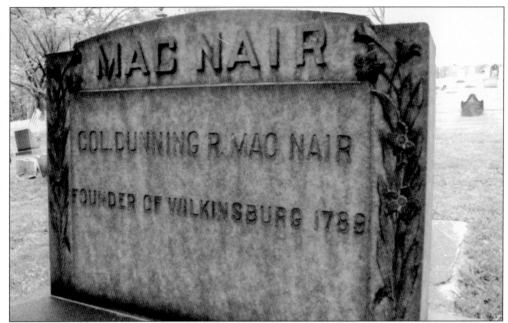

Wilkinsburg's founder, Col. Dunning McNair (1762–1825), rests in Beulah Memorial Cemetery in Churchill. McNair laid out a street plan for the village he named Wilkinsburgh. The McNair family had two homes: the Crow's Nest on the Great Road near Mill Street and later Dumpling Hall on Rebecca Avenue at Hay Street. He served in the Pennsylvania militia and was elected to the state legislature in 1799.

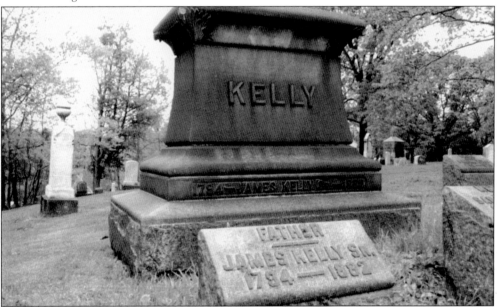

Wilkinsburg's greatest benefactor was James Kelly (1794–1882). He owned over 1,000 acres in the area and donated land for schools and churches. His income came from coal mining, farm rents, limestone production, and supplying wooden ties for the railroad. He also outfitted Union soldiers during the Civil War. Kelly financed the legal battle against Pittsburgh's annexation of Wilkinsburg. He is buried in Beulah Memorial Cemetery in Churchill.

BIBLIOGRAPHY

A Brief History of Wilkinsburg: In Celebration of the 50th Anniversary of the Wilkinsburg Bank, Wilkinsburg, Pennsylvania, 1896–1946. Wilkinsburg, PA: Wilkinsburg Bank, 1946.

Davison, Elizabeth M., and Ellen B. McKee. *Annals of Old Wilkinsburg and Vicinity: The Village 1788–1888*. Wilkinsburg, PA: Group for Historical Research, 1940.

Dean, James A., and George M. Kurth. *The Nugget: Golden Jubilee, 1887–1937*. Pittsburgh: James A. Dean and George M. Kurth, 1937.

Dudley, E. H. *Dudley's Directory of Wilkinsburg*. Pittsburgh: E. H. Dudley, 1897.

Dudley, R. L. *Dudley's Directory of Wilkinsburg*. Pittsburgh: R. L. Dudley, 1894.

The Gem: Wilkinsburg's Diamond Jubilee: Celebrating 75 Years as a Borough, 1887–1962. Wilkinsburg, PA: Grant H. Leisch, 1962.

Gilchrist, Harry C. *History of Wilkinsburg, Pennsylvania*. Wilkinsburg, PA: Harry C. Gilchrist, 1927. Reprint, 1940.

Historic Wilkinsburg 1887–1987, One Hundred Years of Pride. Salem, WV: Wilkinsburg Centennial Publication Committee, 1987.

Polk's Wilkinsburg (Allegheny County, Pa) Directory. Pittsburgh: R. L. Polk and Company, 1939.

Polk's Wilkinsburg, Edgewood, and Swissvale, Pennsylvania Directory. Pittsburgh: R. L. Polk and Company, 1922–1923.

Polk's Wilkinsburg, Edgewood, and Swissvale, Pennsylvania Directory. Pittsburgh: R. L. Polk and Company, 1926.

Souvenir Book: Silver Anniversary 1887–1912. Wilkinsburg, PA: Borough of Wilkinsburg, 1912.

Wilkinsburg Fire Department 100th Anniversary Book, 2003. Wilkinsburg, PA: Wilkinsburg Fire Department, 2003.

ACROSS AMERICA, PEOPLE ARE DISCOVERING SOMETHING WONDERFUL. *THEIR HERITAGE.*

Arcadia Publishing is the leading local history publisher in the United States. With more than 3,000 titles in print and hundreds of new titles released every year, Arcadia has extensive specialized experience chronicling the history of communities and celebrating America's hidden stories, bringing to life the people, places, and events from the past. To discover the history of other communities across the nation, please visit:

www.arcadiapublishing.com

Customized search tools allow you to find regional history books about the town where you grew up, the cities where your friends and family live, the town where your parents met, or even that retirement spot you've been dreaming about.